THE IDEA OF LOUIS SULLIVAN

THE IDEA OF LOUIS SULLIVAN

JOHN SZARKOWSKI

With an introduction by Terence Riley

BULFINCH PRESS

LITTLE, BROWN AND COMPANY

BOSTON · NEW YORK · LONDON

NEW EDITION

Library of Congress Catalog-in-Publication Data
Szarkowski, John.
 The idea of Louis Sullivan/ John Szarkowski with an introduction by Terence Riley.
 p. cm.
 Originally published: Minneapolis: University of Minnesota Press, 1956.
 ISBN 0-8212-2667-3
 1. Sullivan, Louis H., 1856-1924 – Sources. I. Title.
 NA737.S9 S9 2000
 720'.92–DC21
 00-037840

Bulfinch Press is an imprint and trademark of Little, Brown and Company (Inc.)

Designed by Jerry Kelly
Digital photography and duotone separations by Robert J. Hennesey

Printed and bound in Germany by Cantz

TABLE OF CONTENTS

Preface to the new edition VII

Introduction by Terence Riley XIII

Photographer's foreword to the 1956 edition XVII

Prologue 3
The Farmers and Merchants Union Bank, Columbus, Wisconsin

Profile of Louis Sullivan 19

I End and a Beginning 31
 The Auditorium, Chicago

II Steel, Art, and the Engineer 57
 The Wainwright Building, St. Louis, 1890

III The Skyscraper and the City 73
 The Schiller (later Garrick) Theater, Chicago, 1891–92. Demolished, 1961.

IV New Captains and a New Creed 85
 The Stock Exchange (later 30 North LaSalle Building), 1893–94. Demolished, 1970–71.

V Function (Idea, Spirit) and Form 101
 The Guaranty (now Prudential) Building, Buffalo, 1894–95

VI The Victory of the Higher Culture 121
 The Getty Tomb, Graceland Cemetery, Chicago, 1890
 Holy Trinity Russian Orthodox Cathedral, Chicago, 1901–2
 The Bayard (now Condict) Building, New York, 1897–98

VII Defeat: The Crucible 139
 The Schlesinger-Meyer (now Carson Pirie Scott) Department Store, Chicago, 1899–1904
 The National Farmers (now Norwest) Bank, Owatonna, Minnesota, 1907–8

A Technical Note on the Photographs 162

PREFACE TO THE NEW EDITION

OLD MEN should not revise young men's work; they are certain to make a botch of it. This is true even if, or perhaps especially if, the old man was once the young one. An extension of this principle might dictate that old men should not even comment on the work of their youth, for fear of demonstrating that they have failed utterly to understand it. I am inclined to obey that injunction also, except to say, in reference to *The Idea of Louis Sullivan*, that it seems to me most improbable that the book ever reached the dummy stage, and astonishing that it was actually published.

The work was begun because I had been captivated by Sullivan's *Kindergarten Chats*, brought back into print in 1947 by Paul Theobald — an act that was surely crucial to lives other than my own. I think that the book was brought to my attention by my great, now late, friend Arthur Carrara, the Chicago architect; he was in any case my guide to Sullivan's great book, and the one who encouraged me not to be concerned about the passages of windy rhetoric but to get on to the good parts. I think it was Carrara's position that any serious American had a God-given right to write a little bad Whitman during his or her life. Even before that, the very talented, sadly short-lived designer Carol Kottke had shown me the great Sullivan bank in her hometown of Owatanna, Minnesota.

The Owatanna bank was obviously great, but when I saw my second Sullivan building — the Chicago Auditorium — it was covered with dirt, bad free-enterprise signage, after-market fire escapes, and an encompassing mantle of civic unconcern. It was in addition not, in any clear sense, a work of modern architecture as I understood the term. In some ways this made Sullivan even more interesting, since less simple.

In 1951 I accepted a position teaching photography (plus, as necessary, subjects about which I sometimes knew very little) at the Albright Art School, in Buffalo, New York. I accepted the job chiefly, I think, because I knew that Sullivan's Guaranty (now Prudential) Building was there. (It is also true that I was at liberty and that I do not remember receiving any other plausible offers.) The Guaranty is possibly the greatest of Sullivan's tall buildings (although the old Stock Exchange Building in Chicago was surely greatly underrated), and I suppose one could have photographed it forever; but after two years I thought I had it down well enough and decided that it was time to move on, to continue what was by now a clear ambition: to do a book of photographs, critical in nature, of Sullivan's best buildings, accompanied by text that might illuminate his own thought and the circumstances in which he worked. I therefore moved to Chicago, where I assumed that my technical and artistic skills, exercised during the week, would enable me to make a decently comfortable living, leaving me leisurely weekends to continue my Sullivan project. It did not work out that way, but that is another long, comic story.

Before leaving Buffalo, I had applied for a Guggenheim Fellowship. Although I had not yet attained the thirty-to-forty age group that the Foundation then favored, they admitted to making exceptions; and in any case, friends who had applied unsuccessfully assured me that one never got a Fellowship on one's first try, so it was good to get the inevitable first rejection out of the way while still young. Nevertheless, I prepared my application as though I might be favored. Edward Steichen and Beaumont Newhall, the two most prestigious curators of photography at the time, knew my work and agreed to support my

candidacy. Edgar Kaufmann Jr., formerly head of the Department of Design at the Museum of Modern Art and a leading critic on Frank Lloyd Wright, had also seen my portfolio of prints on the Buffalo building and had agreed to support my application. It then seemed to me that if Frank Lloyd Wright himself was on my side, I might have a real chance, underage or not.

It is my recollection that I did attempt a few sketches of letters to Wright, generally late at night, on the backs of shirt cardboards, but they were always too long, too conditional, too full of my problems, my ambitions, my priorities. He, or his secretary, would never get beyond the first paragraph. I then decided that the letter — an inflected, narrative form — was inappropriate, and that the telegram — a pungent, heroic form – would be the right thing.

With the telegram form, the timing of its arrival was essential. At the end of the spring term I would be driving back home, from Buffalo to northern Wisconsin, and would be passing very close to Spring Green, and Wright's home. The telegram should reach him about twenty-four hours before my ETA, or perhaps eighteen hours would be better: "Will be in neighborhood tomorrow early p.m. with interesting proposal," but reworded to sound less like the scam of a traveling salesman. I cannot remember where I was eighteen hours before Spring Green, but I think it was dark, and no telegraph office was in sight. But a phone call would be better in any case, less pretentious than a cable. Madison might have been a good place from which to call, but it was still mid-afternoon, and I thought Wright might be having a late lunch, from which it would be unwise to interrupt him.

I arrived at Taliesin realizing that, out of craven cowardice and flaming incompetence, I had blown my chance. In an effort to retrieve some fragment of self-esteem, I took my camera and tripod from the trunk and began to look at the early Wright buildings that he had designed for his mother's Froebel school, which in 1953 were devoted to the drafting rooms of Wright's apprentices. As I began, rather listlessly, to look for a picture that might warrant de-

veloping, I heard a young but officious voice ask me what I was doing. I removed my head from under the focusing cloth and replied, I hope politely, that I was trying to make a photograph. The young man asked whether I intended to publish the picture, and I said no, that I was just trying to see if it could be made. Okay then, he said, but if you wanted to publish it you would have to see Mr. Wright.

As he turned away, hoping to find a more interesting miscreant, my senses came back to me, and in the nick of time I cried out, No! I have changed my mind; I do want to publish the photograph. And the young KGB intern said, Well, okay, here comes Ralph with the pickup, he will drive you back to the house; I threw my camera back into my car, grabbed my portfolio, and was driven over a quarter mile of beautiful, rolling Wisconsin River prairie to the business entrance of Wright's own house. As I entered I saw (I later learned) Wright's longtime secretary Gene Masselinck at the guardian's desk, editing by phone, with the concurrence of some other great man's secretary, what must have been a ten-thousand-word telegram on some immense project. The other man might have been the secretary of the Shah of Iran. I stood for a while, and then, after what seemed to me a nod of Masselinck's head in my direction, I sat down. A little later, in response to what seemed another nod in my direction, I began to pace.

In Wright's houses there are few doors, except for those leading to bathrooms and bedrooms, and as the span of my pacing grew longer, I suddenly saw, not far away, an old model of Unity Temple, one of his very greatest buildings, and I naturally went forward to appreciate it.

I had hardly begun this pleasure when from over my shoulder came a deep, stern voice asking, Yes? And who are you? and I turned to find myself being stared down on by a white-haired giant. It is true that I was stooping to consider the model, but he was in any case clearly a giant. I finally managed to pronounce my name, and say that I had under my arm a portfolio of photographs of Louis Sullivan's Prudential Building. You mean Guaranty Building, he said. Yes, I mean Guaranty Building, I said. He then led

me across the room to a huge drafting table, and I realized that I had stumbled into his private studio. There he took my portfolio, untied the binding strings, and without a single comment or change in expression went through its fifteen or sixteen prints. Then he closed the portfolio, turned it over, and started through again, this time more slowly. Every other print, approximately, he would lift from the portfolio and put in a separate pile. By this time — some minutes after the test had begun — I was sure that these were being singled out for ceremonial burning, perhaps along with their maker. Finally he closed the portfolio and said, "I will take these. They are the best photographs of a Sullivan building that I have seen." In a great rush of gratitude and relief, I tried to thrust the entire portfolio on him, but he stood his ground and accepted only the six or seven that he had already chosen. The interview was concluded swiftly, and soon Ralph was driving me back over those beautiful rolling hills to my car, where I carefully repacked my camera and continued my journey north, feeling that I might after all do some useful work in my life.

In the spring of 1954 the magic letter arrived from Dr. Henry Allen Moe, head (and, in fact, inventor) of the John Simon Guggenheim Memorial Foundation. He congratulated me on having been appointed a Guggenheim Fellow and added that I had been granted a stipend of $3,250 to pursue my Louis Sullivan project. During the next year I worked like a stoker and lived like a sharecropper, and by the summer of 1955 the book was close to finished, in dummy form. I wrote to Gene Masselinck and asked if I might show it to Mr. Wright. A date and hour were set, and I was there on time. Wright was cordial, almost friendly, and the meeting was a great pleasure for me — better than a pleasure, a reinforcement.

Wright had been Sullivan's chief draftsman from 1890 to 1893, but he was (it seemed to me) remarkably modest in claiming credit. He did say that he had designed the window detail on the tower of the Schiller (later Garrick) Theater, and pointed very carefully to the miniscule area on a distant general view. He could see the quality of his work there, and I finally admitted that yes, I also could see what he was explaining. When we came to my photograph of the Wainwright Tomb, he turned to me and asked, "Who is that other young fellow who did a book on Sullivan?" I did not at that time think of Hugh Morrison as another young fellow, but he had done the only book on Sullivan that I knew of, so I offered his name. "He teaches in one of those Eastern colleges," Wright said. Dartmouth, I believe, I said, and Wright said: "That's the one. He said that this [jabbing his finger at the image of the Wainwright Tomb] was one of the best things that Sullivan ever did. [Pause.] It is not only not one of the best things Sullivan ever did, it really isn't any good at all. No one with any sense of proportion would put that dinky little dome on those massive haunches. No one with any respect for the structural nature of stone would put that little drip ledge on the thing and call it a cornice. Nobody with any understanding of the difference between modeling and carving would try to impose that clay ornament on limestone . . . ," and he went on at length, explicating the work's virtually endless failings. Then, turning the picture over with a dramatic *slap*, he added, "Not only that. Sullivan didn't do it. I did it."

After that I took the last of my Guggenheim money and went to New York, not by coach but by sleeper (upper berth), since I felt it essential that I get into a relatively prosperous frame of mind before I could effectively talk man-to-man with the big-time publishers who had written to me after I had been notified of the Guggenheim, telling me how glad

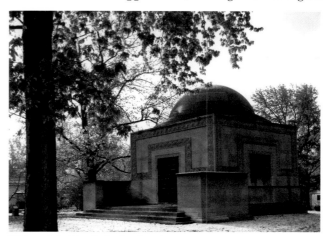

Wainwright Tomb, St. Louis, 1892–93

they were, etc., and how much they hoped I would keep them informed, etc., and let them see, etc. I have wondered since whether they wrote those letters to everyone who received Guggenheims for book projects or whether they excluded, for example, the man who was studying the incidence of blister rust in the white pine after slash fires in the Upper Peninsula.

The publishers that I visited were uniformly cordial and, in fact, genuinely interested — it seemed to me — in my book. The pattern at each publisher was remarkably similar: after forty-five minutes with an enthusiastic thirty-five-year-old editor, a fifty-year-old editor would be called to join in the meeting, who would also prove to be enthusiastic, and who would eventually call in a white-haired editor who (being busier, and more pressed for time) was enthusiastic immediately but who would finally note that the book would not be cheap to print and that the market was limited. No one at any of the publishers I visited said that I should not call them, they would call me, but after two or three days I began to feel that perhaps I should have traveled by coach.

Finally I decided that I should visit the J. S. Guggenheim Foundation, to pay personal thanks. Again I had not announced my visit, and I turned into the marvelous Fred French Building, a toy skyscraper with polychrome terra-cotta, with the guilty sense of one turning oneself in to the principal's office before actually being caught. I found the floor and room number on the brass-bound directory in the lobby and delivered myself to the correct floor. On opening the door, I confronted a sternly beautiful woman the age of my mother. My name is John Szarkowski, I said, and I . . . and she rose from her desk, the sternness all gone, and said, "Mr. Szarkowski, it is so good to meet you; Dr. Moe will be so happy that you are here," etc. Her greeting, and Moe's enthusiasm, made the whole effort worthwhile. Well, perhaps not quite, but they helped immensely.

After that there was nothing to do but go home, put the book in a trunk, and go back to ordinary work. Before I did that, I stopped, on impulse, at a Fifth Avenue street telephone, which in those days still had directories chained to a shelf on which one could read them. I looked up the number for *Fortune* magazine, where I had heard that Walker Evans worked. A switchboard operator answered, and I asked to speak to Mr. Evans. In a moment a voice said, yes, or perhaps, Evans here, and I in a great rush gave my name, the nature of my project, the fact that I had been on a Guggenheim Fellowship, and my deep desire to have him see the work, for no practical reason. He would be happy to see it, he said, when might I be free? I was free now, I said, but was catching the six o'clock train to Chicago. Where are you? he said, and I said I thought I was three blocks away. Well, why don't you come over now, he said, giving no sign of astonishment.

He was physically a great surprise. I think I had expected someone resembling Gregory Peck in one of his rural, slow-talking roles — a man with big hands and big feet, and clothes that he might have inherited from his uncle the country preacher; instead, I was confronted by this little dandy — a superior commuter, with his polished cotton suit and Jermyn Street tie and Lobb shoes and stylish spectacles. Nor could I have expected the great generosity with which he received me and my project. He went through the dummy slowly, with what seemed genuine pleasure, and he devoted the most time, and the best words, to the pictures that I had also thought the best. This was enormously supportive, for after working alone for a long time, one can begin to fear one's judgments are merely personal.

Evans had done considerable photography in Chicago for *Fortune* and knew many of the same locations that I had worked in, which added a quasi-collaborative element to our conversation. He was especially flattering about my picture looking from Clark Street toward the Gold Coast, and the Wrigley and Tribune Buildings (page 153). How right I was to include the trolley wires, he said; how could he have been so dumb as to work so hard to avoid them.

Before I left Evans' office, I was as good as new, though no closer to getting my book published. He asked what I would do next, and I said that I would have to go back to ordinary work. For a moment we contemplated that unhappy fate in silence, and then

I added that I might try to stay alive by freelancing and that if the magazine needed something done in the Midwest, he might suggest my name. No, he said, I won't do that. This magazine is not the kind of place for people like you and me.

It was the most flattering rejection I have ever received.

Back in Wisconsin I had begun to pack for reentry into the other world when a check for five hundred dollars arrived from Edgar Kaufmann, in payment for photographs of Unity Temple. I had intended the pictures as a gift, but under the circumstances, I gratefully accepted the new arrangement and stopped packing. I was living in my parents' house and could make five hundred dollars last for months.

Not much later I got a letter from Helen Clapesattle, director of the University of Minnesota Press, saying that she loved the book and wanted to publish it. She did not mention the fact that it would be expensive to print or the fact that the market was not large. This may in part have been because Clapesattle was almost surely the press's best selling author. Her book *The Doctors Mayo* had for several years sold in a class not far below that of the Bible and the Boy Scouts' Handbook, and it may have been felt that she should be allowed a reasonably free hand in how she spent the profits. In any case her decision was a disinterested, professional one, and I remain no more grateful to her than I would had she saved me from drowning.

The book was published in 1956 and was for the most part very generously received. Nevertheless, it is perversely true that in retrospect the unsympathetic reviews are more diverting than the friendly ones. Philip Johnson (*ARTnews*, December 1956) did not like it, but that was during his high classical period, and I think it was really Sullivan he did not like, except to the degree that his work could be made to resemble that of Mies van der Rohe. Reyner Banham (*Architectural Review*, March 1958) felt much the same, but expressed himself with greater comic relish, and spoke of my fascination with Sullivan's ornament, "in all its vegetable obsessiveness."

Six years later I joined the staff of the Museum of Modern Art and soon became friends with Evans, whom I saw with some regularity. Nevertheless, I don't think that our earlier meeting was discussed. I don't mean that the subject was avoided; it was history, and it did not arise. After I had been in New York for some months, Henry Allen Moe (who was also the chairman of my Trustee Committee at the museum) asked me if I would become the Foundation's referee for photography — the person who recommended which candidates should be awarded Fellowships. I answered that I was deeply honored to be asked but that I felt I had my hands full with my museum job and was afraid that I wouldn't be able to give the Guggenheim the time it deserved. Oh, Moe said, I don't think it would take too much time. You could ask Walker; he doesn't want to do it anymore. I said, Do you mean Evans has been your referee? And he said, Oh yes, Walker has done it for us for many years.

INTRODUCTION

TERENCE RILEY

AT THE OUTSET, it seems important to underscore that John Szarkowski's *The Idea of Louis Sullivan* is not a book of photographs of Sullivan's work, nor is it a biography. Rather, it is an immensely sensitive portrait of the architect as a thinker, seen through images of his buildings and excerpts of his writings. Acting principally as a photographer, but contributing greatly as an editor, interviewer, and essayist, Szarkowski evokes Sullivan's enormous creative capabilities, both intellectual and productive, as they might be gleaned in the well-known midlife photographic portrait of 1900. Neither hagiography nor reportage, it should also be mentioned that Szarkowski's portrait is not a hermetic psychobiography (there have been enough of those of late) but one that includes a profound understanding of the stage upon which Sullivan's dramatic life was acted out — most importantly Chicago and its Midwestern culture.

The republication of this book is a reason for many to celebrate: photographers, architects, and anyone interested in the relationship between the ways things look and what they mean. It comes at a time when the air has cleared somewhat of the rancorous debates surrounding the rise of postmodernism. In architectural circles this discourse pitted, rather simplistically, tradition against innovation as the fundamental source of architectural inspiration. A deficiency in this argument was such that over the past two decades or more Sullivan, not to mention Frank Lloyd Wright, Louis Kahn, Eero Saarinen, and others, dropped out of the picture: too radical for the orthodox and too synthetic for the avant-garde. If anything has been learned from this exclusion, it is that Louis Sullivan and his work are simply too complex for such reductivist views of history.

Sullivan also famously turned away from European precedents in seeking an architecture that was appropriate to the American experience. Once again this issue is relevant to contemporary discourse. As the current fascination with poststructural philosophical theory winds down, the uniquely American philosophical inquiries established by William James under the rubric of Pragmatist thinking are of interest once again. James's methodology, which proposed a theorization of the present, a bridge between practice and theory, grows out of the same currents that guided Sullivan's hand.

By focusing on the life of the mind, Szarkowski brings us closer to Sullivan than the subject, or any subject, might have wished. The shift from objective, connoisseurial appreciation to a more intimate and nuanced understanding of Sullivan's life and work brings with it a demand for greater effort on the part of the reader. It requires looking beyond surfaces and forms, more reflection on the nature of artistic activity, and a much more sympathetic grasp of the perplexing combinations of protean creativity and mundane frailty that define the lives of so many great artists. In the case of Sullivan, whose moments of architectural achievement were often commingled with bouts of extreme personal and emotional dissolution, many biographers and readers have frequently found it convenient to draw the veil of genius over the architect's intellectual life rather than probe beneath the surface of the work. Furthermore, photography has often served to illustrate the biographer's prose, which in the case of a great artist more often than not reduces the work to the level of the writer's skill. Szarkowski's book acknowledges that any real understanding of Sullivan's work on the part of the reader derives from the leap from the

image to the idea — in effect, tracing in reverse the path Sullivan himself took.

Like all intimate portraits, *The Idea of Louis Sullivan* reveals as much about the author as the subject. In this instance, Szarkowski shows himself as a gifted young photographer whose skills were honed since taking up the camera as a teenager, with an instinctive appreciation for the sensibilities that are best portrayed in architecture. Unsurprisingly, Szarkowski's architectural interests were close to home, reflecting his Midwestern upbringing in Ashland, Wisconsin. Four years before beginning the photographic project that would become *The Idea of Louis Sullivan,* the architect's most renowned pupil, Frank Lloyd Wright, completed his designs for the Unitarian Meeting House in Madison, Wisconsin, where Szarkowski attended the University of Wisconsin. The commission for the prowlike structure followed the construction in 1936 of a small house for Herbert Jacobs, a local Madison newspaperman. Referred to by Wright as a "Usonian" house, the Jacobs House and the Unitarian church established domestic and public architecture prototypes, respectively, that would vastly transform the American landscape in the coming decades.

Wright's prominence in Szarkowski's formation was due to both his lofty presence at his self-designed atelier and manor house in southern Wisconsin, Taliesin, and his domination of the architectural culture of Chicago, the metropolitan hub whose influence radiated throughout the Midwestern states. Any interest in Wright's work would lead, both figuratively and literally, to Chicago and the work of his *lieber Meister,* Louis Sullivan. In the case of this book, these intersections of interest proved a godsend: Wright's purchase of a group of Szarkowski's Sullivan photographs kept the young photographer, then in his mid-twenties, financially afloat at a critical moment.

Szarkowski's attraction to Sullivan and Wright, it should be noted, is such that it can't be characterized solely in terms of art history, which he studied at the University of Wisconsin. In the Broadway show *The Music Man,* the lead character declaims that a proficiency at shooting pool "bespeaks a misspent

youth." Between the two of them, Sullivan and Wright demonstrated a veritable catalog of human foibles: lifelong youths, seemingly impervious to the demands and constraints of adulthood. Sullivan's hard drinking, and the emotional isolation it caused, is tragic in the way that Wright's amazingly crowded love life and spendthrift grandeur would be called comic if it weren't for the high-mindedness with which Wright approached them. Szarkowski clearly displays an empathy for the roguish genius that defined these two lives, and in the case of Wright, there seems to have been a reciprocal appreciation for the young man's talent. (I don't know whether Szarkowski played pool, but convincing Wright to commit funds for his photographs would have been, by all accounts, evidence of certain unique talents.)

The critical attitude that Szarkowski brings to *The Idea of Louis Sullivan* would portend his highly successful career at the Museum of Modern Art, which commenced in 1962, six years after the book first appeared. The "experts" whom Alfred H. Barr Jr., the museum's founding director, called upon to lead the institution were those who had sought out the art and artists that were defining the art of their time. University degrees mattered less than commitment, and academic erudition was less valued than thoughtful analysis of a work of art, its aesthetic qualities, its meaning in a broader cultural context, how it made us think of the past, what its portents for the future might be.

Indeed, Szarkowski's career as a curator at the museum was further distinguished from academic pursuits in that he practiced photography in addition to studying it. Thus, his understanding of the subject was not limited to objective appreciation but was bolstered by a personal awareness of the techniques and process of its making.

Szarkowski also shared a trait that defined many of his MoMA colleagues. Their relationship to the art they studied was frequently informed by first-hand and often deeply personal relationships with the artists they studied, their friends and families. Their experience was gained in conversations with the artists and those that knew them, from visits to their

studios, and in lively and sustained correspondence.

Szarkowski's treatment of Sullivan thus benefits from the specific insights into the personalities of artists, how they think and, most important, how they make things; insights that may often elude the detached historian observer.

From my own experience, it is evident that the best architects have an instinctive grasp for the dimension of history, that all architects, in fact, are historians. The production of architecture requires a suspension of a day-to-day view of life in favor of a longer-term one. It is an inherently time-based activity, the cost and functional demands of which require a conceptualization over years, if not generations. This mode of thinking inevitably leads to a historical perspective that parallels the professional historian yet differs in important ways. Lewis Mumford coined a memorable phrase that might capture this attitude when he spoke of "the usable past," a critical approach to history that could be studied, transformed, and made new in contemporary culture.

In studying this book anew, I realized that Szarkowski had arrived at his own version of Mumford's "usable past," his own internalized historical perspective, the scale of which was derived from his own work as a photographer. In this instance, the meter was not years but seconds, the determining time frame of the photographic exposure. Despite the disparity in scales, both encourage the view that art is intimately bound with time. If the larger scale of time might lead us to measure in generations, the smaller scales lead us to measure in heartbeats; both suggest the measurement of art is life.

The great value of this book lies in the coincidence of these two scales. That Szarkowski has a deep affinity for Sullivan is, as I have argued, due to his own sense of being a maker of things, his rapport with artists as individuals and, no doubt, his familiarity with the particular culture that Sullivan made his own, the city of Chicago. Szarkowski's insights are further enhanced because of his internalization, both as a practitioner and an avid student of the history of photography, of photography's relationship to architecture over the preceeding century and a half.

Since its earliest days, architecture has been photography's most willing accomplice. The physical characteristics of buildings — unmoving yet animated by a daily wash of nature's light — made them far more reliable as subjects than the human figure and its tendency toward motion. I am thinking of the early images of the city of Paris or the monuments of the Grand Tour, the most important of which are known to us today as the signature work of pioneering artists such as Edouard Baldus, Charles Marville, and Robert MacPherson.

Even so, the early photographers' attraction to architecture cooled somewhat, or at least was diverted elsewhere, when technical means allowed them to pursue more animate subjects successfully. Furthermore, by the third quarter of the nineteenth century, architectural photography had emerged as a subspecialty whose goal was more specifically limited to documenting the work of the architect for publication and other purposes. In this case I am thinking of the great number of mostly anonymous photographs, such as those from the 1870s that document the work of the architect H. H. Richardson, which are known to us as primarily illustrations of the architect's work.

The distinction between architectural photography, as a profession, and the photography of architecture, as an art practice, could not be more evident than in these examples. The profession of architectural photographer certainly still exists today, providing clients with images that strive for an ineluctable anonymity and follow a certain stylistic pattern: bright daylit exterior shots and interiors evenly lit by artificial sources. Szarkowski's marvelously moody photographs of Sullivan's work are of singular interest in their ability to bridge the gap between the photographer as artist and the architectural photographer as technician. This ability is most marked in his photograph of the proscenium screen of the Chicago Auditorium, which juxtaposes the vegetal swirl of the cast-iron frieze with the unexpected presence of the fragile skeletal remains of a bird. What is to be made of this? Is the photographer trying to suggest the underlying unity of the organic

structure of both the frieze and the skeleton, of both the inanimate and the animate worlds? Or, perhaps, the inevitable decay and dissolution that afflicted both Sullivan in his own life and his buildings at the hands of unsympathetic developers and commercial interests? Szarkowski's tendency to see art as measured by life would suggest that both interpretations, alternating between the sublime and the tragic, are equally valid.

It is significant that *The Idea of Louis Sullivan* is being reissued at a time when photography's love affair with architecture seems to have been rekindled. A new generation of photographers has chosen, like Szarkowski before them, to look to architecture of known authorship and to attempt to add new dimensions to it.

For example, Andreas Gursky's photos of Gunnar Asplund's Stockholm Library, Norman Foster's Hongkong and Shanghai Bank, and John Portman's Times Square hotel atrium tell us more about the modern world's apparently insatiable tendency to define, categorize, and standardize than the physical characteristics of the buildings themselves. In contrast to standard professional practice, Thomas Ruff's photographs of the works of the Swiss architects Jacques Herzog and Pierre de Meuron put less emphasis on the overall form of the building and more emphasis on their surfaces, provocatively suggesting that the skin of the building, as well as its form, can convey meaning.

Szarkowski's book can be seen as a harbinger of the rediscovered interest in architecture as subject as well as the role of the photographer in interpreting architectural form. It is a complex relationship, not unlike an actor delivering a writer's lines or a musician playing a composer's music. The consequences of overplaying are obvious, but a greater loss might be seen in underplaying. In this instance, self-abnegation would diminish our enjoyment of Szarkowski's great talents as well as fall short in helping us see Sullivan's enormous accomplishment. There may be, for whatever historical reasons, anonymous photographers, but Szarkowski clearly demonstrates that there is no such thing as anonymous photography.

PHOTOGRAPHER'S FOREWORD

WHEN THESE PHOTOGRAPHS were begun, five years ago, it was with the idea of producing an academically serviceable record of the Prudential Building, in Buffalo, New York. My introduction to Louis Sullivan had come in the preceding months, not through his buildings, but through his intoxicating, inspiring writings. These writings showed a man who had demanded wholeness — total humanity — with the passion of few men before or since. So when I went to Buffalo I sought out this building — a tangible product of his thought. The building was old and dirty and largely lost among its newer, larger neighbors. Like a diamond in a pile of broken glass, it stopped few passersby. But it was there to be looked at, and with sympathy and patience it could be seen — and seen to be a masterwork, an image of greatness.

Obviously it was necessary to photograph the building immediately, before it was further defaced. As I began to work I found, to my own surprise, that I was seeing this building not with the decorous disinterest with which a photographer is supposed to approach a work of formal architecture, but as a real building, which people had worked in and maimed and ignored and perhaps loved, and which I felt was deeply important. I found myself concerned not only with the building's art-facts but with its life-facts. (Louis Sullivan had claimed they were the same.) This concern began to show in the photographs, and the idea grew:

When photographers of the nineteenth century first used their cameras to describe formal architecture, they were concerned with buildings the content of which had died, however alive the forms may have remained. The Acropolis was empty, and the pageants on the porches of Chartres were only a souvenir of the great medieval morality plays. Only the forms remained to be photographed. Such an approach became a habit, and then a virtue, until the building in the photograph became as isolated from life as the insect enclosed in the amber paperweight. In our own day perhaps the best architectural photographs have been the casual products of the photographer-journalist, where the life that surrounds and nourishes the building is seen or felt. If to such an approach were added an understanding of architectural form, photography might become a powerful critical medium, rather than a superficially descriptive one.

This is what I have tried to do in this book. The effort has not been to compile an exhaustive documentation of Sullivan's buildings, but rather to re-enliven, by means of photography, the fundamental concepts which were born in his work. In the selection of the accompanying text, the attempt has been less to explain or evaluate than to capture the mind and the spirit of the man and the time and the place. To preserve a just balance between word and picture, and to preserve as much as possible of the writings which seemed revealing, I have been forced to cut text which I would have preferred to quote in whole. But no word or meaning has been changed, and I believe that the flavor of the original has been preserved. Rather than allow the ataxia of ellipsis marks to destroy the rhythm of the original style, I have omitted all ellipses. I hope that this text will bring new readers to their own investigation of the original sources, in all their richness.

This book is dedicated to J. H. and Rosella Szarkowski, my parents, for their unfailing generosity and faith.

I would also like to acknowledge my deep debt to Mr. Frank Lloyd Wright, for his kind encouragement and advice; to Mr. Edgar Kaufmann, for wise counsel and keen criticism, and generous material aid; to Mr. Arthur Carrara, who communicated for his own deep love of Louis Sullivan; to Beaumont and Nancy Newhall, for their most cogent analysis of the photographic and editing problems; and to the John Simon Guggenheim Memorial Foundation, whose Fellowship Grant made this work possible.

Special thanks must also be paid to the following: Mr. H. Harvard Amason, Department of Art, University of Minnesota; Mr. D. S. Defenbacher, California College of Arts and Crafts; Mrs. T. M. Hofmeester, Burnham Library of Architecture; Mr. William Gray Purcell; Mr. Edgar Schenck, Brooklyn Museum; Mr. Edward Steichen, Museum of Modern Art; and the staff of the University of Minnesota Press, especially Mrs. Marcia Schneider.

THE 2000 EDITION of this book would surely not exist except for the enthusiasm of Bill Turnage, who persuaded Little, Brown, and me, to think seriously about bringing it back to life — forty-four years after its first appearance. What had been only a part of my remote past is again a part of my present, and I am enjoying its company. I am also grateful to Janet Bush, who has been responsible for the rebirth of the book and has done so with skill and style, while dealing with the author's sensibilities with unfailing tact and generosity; and to Sandra Klimt, who oversaw the production of the book with an artist's concern for both broad concept and telling detail; and to Robert Hennesey, who supervised with his usual skill and calm the magical and sometimes hair-raising process of converting chemical photographs into photographs in ink; and to Jerry Kelly, for his sensitive revision of the book's design.

John Szarkowski

THE IDEA OF LOUIS SULLIVAN

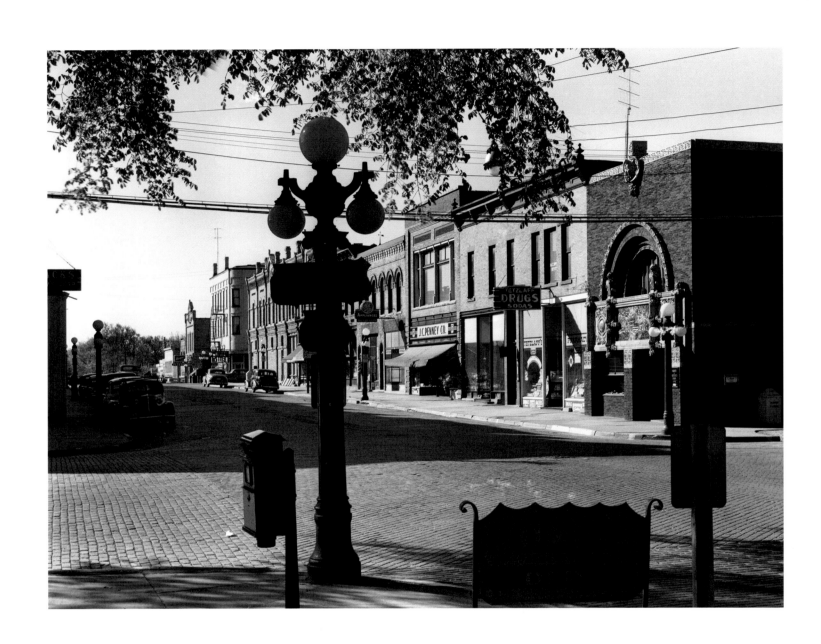

PROLOGUE

MR. J. R. WHEELER, former president, Farmers and Merchants Union Bank, Columbus, Wisconsin:

When we decided to build, all that I knew was that I wanted a good bank building, a place to carry on my business efficiently. Of course I wanted it to look well, but I had no deep-seated prejudices about what that meant. It was really Mrs. Wheeler who was interested in art. She had seen some buildings by Frank Lloyd Wright that had impressed her, and when I came home with a post card of a bank by Sullivan, thinking that it looked like the same kind of thing, she agreed. So we sent for him, to talk about it.

MRS. WHEELER:

I had been studying the Froebel ideas — which were still new, then — at the Chicago Kindergarten Training School. "Do nothing unrelatedly," was really the idea of it. The idea of the organism — of the whole preceding the parts — showed that the smaller idea grows out of the larger. As the hand is to the arm, and the arm to the person, so the person is a part of a larger whole. Mr. Sullivan would say very similar things to me at the table after breakfast, where we would often sit and talk long after Mr. Wheeler went to the bank. "Maggie," he would say to our maid, "you forgot to put any jam on the table." Then he would talk, very beautifully, and sometimes far over my head, I'm afraid. Once I apologized that his philosophy should be wasted on one who couldn't fully understand it. "No," he said. "No, I am a gardener. I recognize good ground."

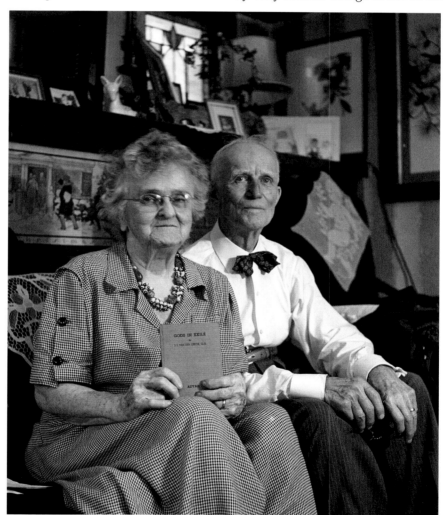

RIGHT: Mr. and Mrs. J. R. Wheeler

LEFT AND PAGES 5–16:
The Farmers and Merchants Union
Bank, Columbus, Wisconsin, 1919

3

J. R. WHEELER:

Well, as far as doing things relatedly is concerned, I tried to do that at the bank, too. Although I thought of it as being just sound banking. We encouraged experimental farming techniques, got the farmers to work closely with the County Agent, promoted a canning industry in order to guarantee the farmers a market, and did other things of the sort. But I had never really thought about these things in quite the same way before I met Sullivan as I did afterwards.

Anyway, he came and stayed with us, and for a couple of days we talked over what I thought our requirements were. Then very quickly he did small preliminary drawings.

I was scared to death by those first drawings. I was supposed to be a conservative man, a fairly distinguished member of a conservative profession, and I was being asked to build a building that looked to me flamboyantly radical. And I was sure that it would terrify the natives. I was almost ready to call the whole thing off and run for cover. It was Mrs. Wheeler who soothed my feathers and talked me into going ahead.

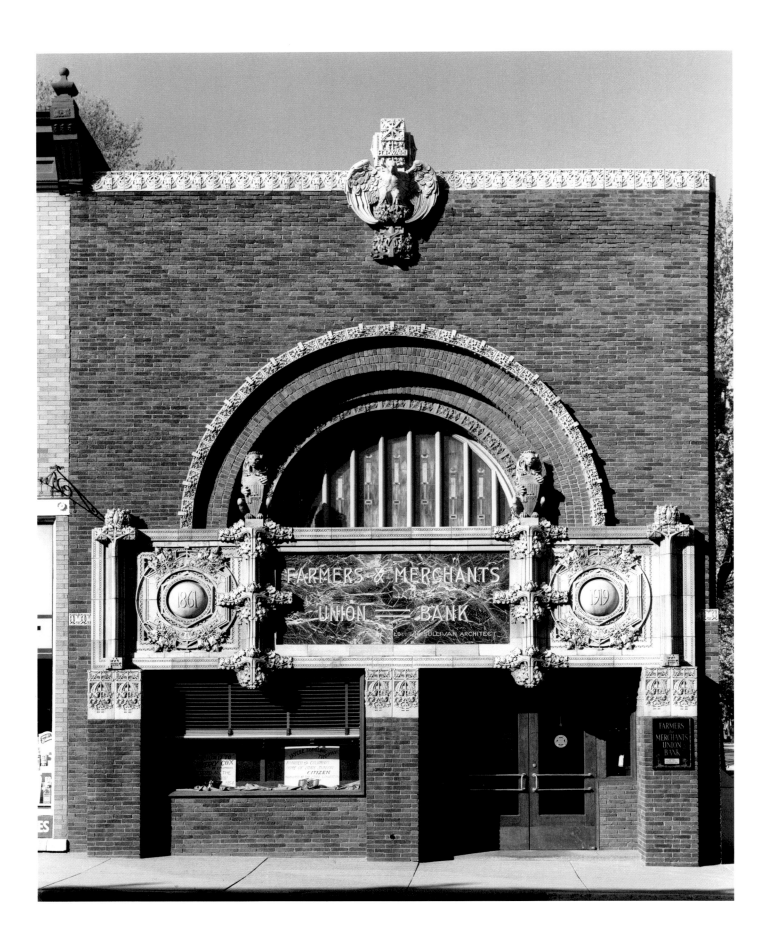

Sullivan came to Columbus often during construction, and always stayed with us. My admiration for him, and then my liking for him, grew continually stronger. He had a pride and an independence of mind that I had always been taught to admire. But I had never before seen it expressed the way Sullivan expressed it, and it took me time to learn to understand. I had looked into Sullivan's history before we first contacted him, and of course I understood that we would never have been able to afford him if he had not fallen on bad days. As time went on I began to hope for a big success for the building in terms of what it might do for him, by attracting new commissions.

From my original timidity, I eventually advanced to the point where I began to worry that somebody else might copy the bank. I asked him once, while we were walking home for lunch, if such an original solution was not liable to be copied. "No," he said. "It won't be copied. It can't be copied." I understand now more of what he meant, but at the time it seemed like a shockingly egotistical thing to say. And that was not the only time. Once when cost was seeming like a great problem, I said that I guessed he would bankrupt me, but that there was no turning back now. He stopped and turned to me, and said, "Just remember: you will have the only Louis Sullivan bank in the state of Wisconsin."

J. R. WHEELER:

In spite of my worries over cost, there were very few changes from the first drawings. The elimination of the skylight was the only major one. And on either side of the public writing desk, he had indicated a large terra cotta lion. I just could not accustom myself to the idea of our customers coming in with their milking clothes and standing between those two lions. I really thought that they would feel intimidated. Afterwards I was sorry to have argued about such details.

Strangely enough, the only difference that threatened to become serious pertained to the design of the vault. Sullivan wanted to reinforce it very heavily with steel, and even the insurance company could not see that it need be so strong. I think that he could not bear the idea of anyone ever breaking into a Sullivan vault. You know, he never referred to this building as a bank. He always called it his jewel box.

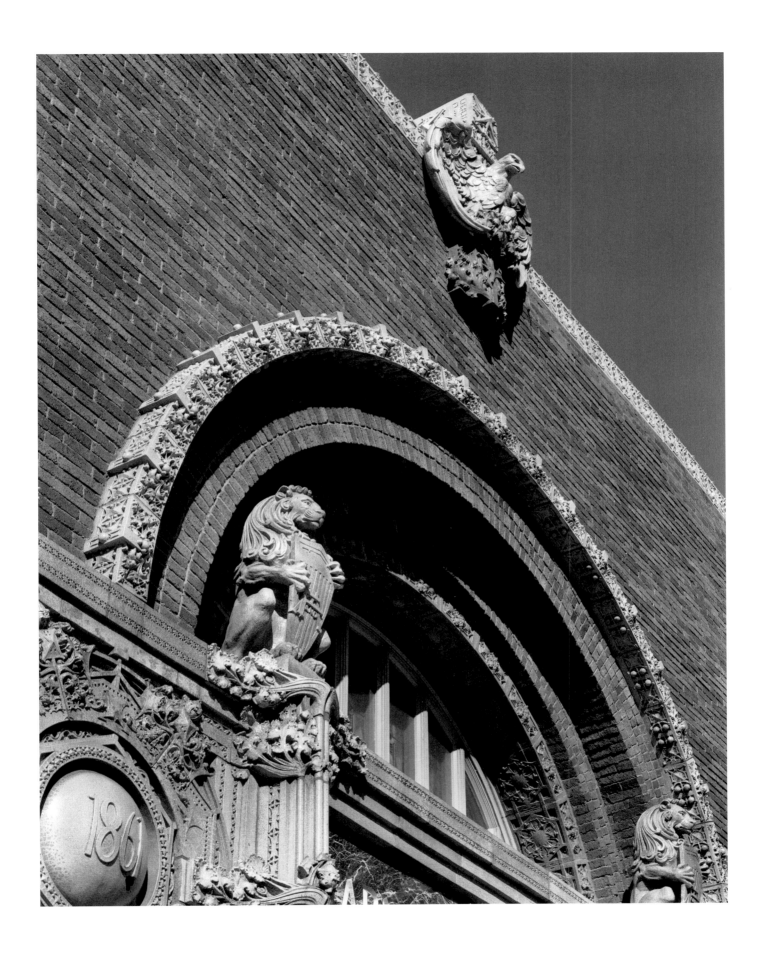

J. R. WHEELER:

When Sullivan learned of Mrs. Wheeler's interest in Frank Lloyd Wright, he arranged to have us meet him at the Park Hotel, in Madison. All I remember now is that Wright said, when we were introduced, "You are very fortunate at having the Master with you." That has always stuck in my mind. For some reason, we did not have lunch with Wright and his wife, for which my wife, I think, has never forgiven me.

The bank was well along by now. The terra cotta ornament seemed very expensive, and no one was good enough to model it, according to Sullivan, but this man Schneider. Finally I went to see Gates, the head of the terra cotta company, and questioned him about his prices — rather bluntly, I'm afraid. He told me in no uncertain terms how lucky I was, that he was making no money on the contract, and that for anyone but Louis Sullivan it would be much higher. Gradually I came to realize what I was getting.

When the bank finally opened, the people did not seem shocked, as I had at first feared. In fact after my relief had worn off, I was sorry that they did not seem more excited about the building than they were. But then, they had not had the chance to know him, as I had.

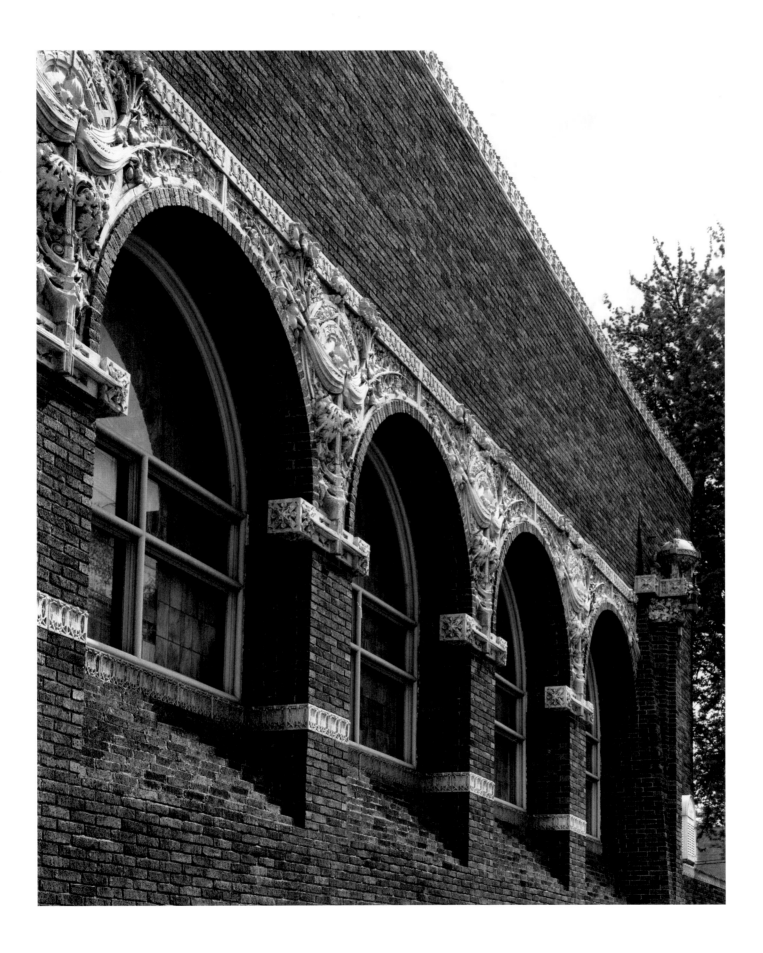

To CARL IBISCH, builder, Columbus, Wisconsin

"... If you are in doubt about any matter refer it to me promptly: otherwise use your best judgment in carrying on the work to completion in the spirit of my drawings and specifications. Very soon it will be necessary for you to do less work with your own hands and give all the time necessary to direct superintendence, and to anticipating and managing for future requirements, so that the work of all trades will combine into a finished whole, and blunders will be avoided: In other words I look to you to be the directing brain of the actual work...."

<div align="right">

LOUIS H. SULLIVAN
1808 Prairie Avenue, Chicago
December 22, 1919

</div>

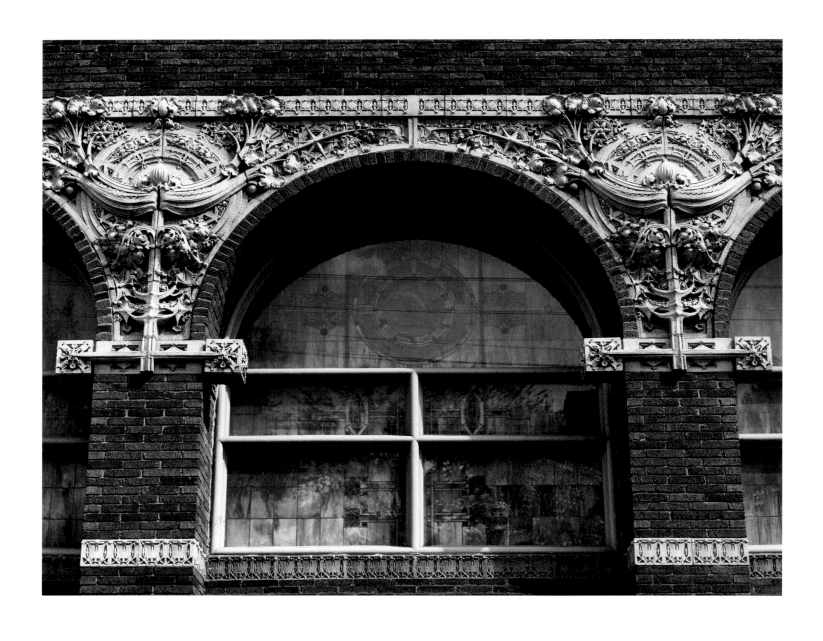

Seeds are the final product of the flower,
to which all its parts and offices are subservient.

ASA GRAY
Gray's School and Field Botany
(a lifelong text of Sullivan's)

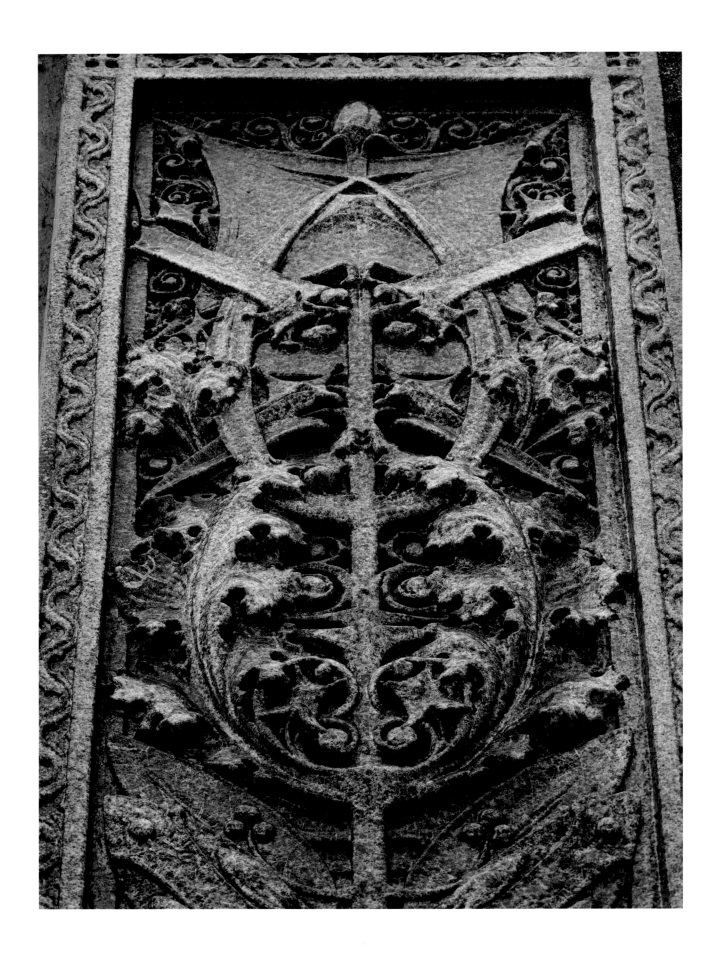

16

FREDERICK WAGONER
American Terra Cotta:

Sullivan's last commission? Well, he drew the façade for that little music store that Bill Presto did up on Lincoln Avenue — in 1922, I believe. But his last commission was not a building at all. Some hardware company had him do an ornamental design for one of those tin platforms that stood under the old pot-bellied stoves. His fee was two hundred dollars, as I recall. I don't know whether the thing was ever produced or not.

PROFILE OF LOUIS SULLIVAN

AMERICA IN 1890 thought (as by and large she still thinks) that her architecture, like her dress, was a matter of taste. And as things stood she was largely right; for both buildings and clothes were conceived as costume, aiming chiefly at camouflage of the reality beneath. And both were offered in bewildering variety: did the client care for leg-of-mutton sleeves; or a bustle in the back? Or a gilded dome on the city hall? Or gargoyles on the college? These and other choices beyond number were available, and how was one to be selected above the others, if not by the divine intuition of connoisseurship? Indeed, taste of a high order, and quick reflexes, were required of one who would remain *au courant* as this stream of fashion sped on its unpredictable way.

Louis Sullivan dissented, suggested that fraud was involved, and said besides that the system wouldn't work. We have no free choice, he said, in expressing what we are; our true likeness would show beneath the cleverest costume. We can choose only what we are to *be*, and the choice is indelibly stamped on our works. For to this man architecture was not style: it was the record of human belief and aspiration; like the needle of the seismograph, plotting the movement of our silent thought. Sullivan said that we built what we were, and we were what we built.

Louis Sullivan, at least, was what he built: a lyric poet by nature, an American pioneer in the strength of his desire, a cosmopolitan in breadth of mind; brilliant, outspoken, inventive: an American Master.

The Master's father was an Irish dancing master, devoted to grace and symmetry of manner, and to the Spartan rigors of an athlete's life. The mother was a delicate dreamer who sang in French. The place at first was Boston, and soon afterwards the Massachusetts countryside, and the farm of Louis's grandparents, where for six years the boy watched the seasons pass, and came to know nature's processes. "The School did not give me my start," he wrote some forty years later. "The real start was made when, as a very young child living out of doors, I received impressions from the shifting aspects of nature so deep, so penetrating that they have persisted to this day. . ." (Letter to Claude Bragdon, July 25, 1904.) And with these impressions from nature came the rhapsodic imaginings that will carry a child deep into reality.

This sweet free poetry of a boy's mind was first harnessed by a master of Boston's English High: Moses Woolson. Woolson was a man with a passion for teaching, a benevolent despot who handled his boys with an exacting precision. On the first day he defined the problem: "You are here as wards in my charge; I accept that charge as sacred; I accept the responsibility involved as a high and exacting duty . . . I will give you all that I have, and you shall give me all that you have. I shall not start you with a jerk, but tighten the lines bit by bit until I have you firmly in hand at the most spirited pace that you can go!" (*Autobiography of an Idea*, pp. 158–59.) Louis was overjoyed, intoxicated by the sudden intimation of organized human power, of the FORM which could contain and define the welter of his boyish intuitions.

Under Woolson's guidance Louis changed from a wide-eyed wondering child to a young mental athlete, thrilled by the adventure of disciplined mental effort. His performance was sustained by the power of Woolson's personality, and when Louis was promoted to the following form, and a master cut from humbler cloth, he returned to the reverie of his imaginings. After one year — his second of high school — he despaired of finding another Woolson,

and so took, and passed, the entrance examinations of the Massachusetts Institute of Technology.

For the boy had decided, some years earlier, against "scientific farming," and in favor of architecture. It had been buildings themselves that had first attracted him; he had listened to their messages: some spoke in pompous, pessimistic weariness, some in respectable prudence, one at least in a spirit of freedom and joy.

Then later, a construction worker had identified the dignified man with the tall hat and the full beard, who rode in his own carriage. He was the "archeetec." Louis was interested. "Sure. He lays out the rooms on paper, then makes a picture of the front." Louis was incredulous, the workman patient. "Sure, there's an archeetec for every building." And the building that was Louis's favorite: how had the archeetec made that? "Why, he made it out of his head . . ."

As Sullivan remembered it many years later, that was that. The boy had chosen.

At "Tech" Louis was politely interested, and vaguely resentful. Intuitively, he felt that the pious study of classical orders, the idolatrous drawing of plaster casts, had little enough to do with what *he* had in mind — with the image of his boyhood hero: the man who made buildings out of his head. After a single year Louis left, determined to find a fuller answer in Paris, at the École des Beaux-Arts.

But first there was an exploratory fling in a practicing office. A happy half-year in Philadelphia, with Hewitt and Furness, ended with the panic of 1873, after Jay Cooke had closed his doors. Sullivan tried Chicago next, and for another six months worked for Major William Le Baron Jenney, the same who would later build the world's first steel frame building. It was difficult for Louis to take Jenney seriously as an architect, but here he met John Edelmann, a young draftsman who was to join the list of Louis's heroes. Edelmann — brilliant, undisciplined, and self-indulgent — had found an appreciative audience. Sullivan had found a substitute for Moses Woolson: a mind that could force his own to its limits. Together the pair explored philosophy, politics, Richard Wagner, the new science, and, on occasion, architecture. To Edelmann, this talk was the frosting of vanity; to Sullivan it was solid nourishment. Thus was Louis's education continued.

In the following summer Sullivan sailed for Paris, fountainhead of the true and the beautiful in architectural learning. Again there was a period of high excitement, of effort under pressure, as he prepared for the rigid entrance examinations, only six weeks away. In a prodigious, concentrated effort, he mastered material normally gained only through years of academic preparation.

Sullivan passed the examinations brilliantly; but again, when the artificial stimulus was past, his interest began to waver. He fully appreciated the grace and elegance, and the rational precision, of the solutions produced by the Beaux-Arts system at its best. But this system — a distillation of the past's most brilliant achievements — was at bottom an intellectual abstraction; it failed to uncover the living reality that Louis sought. His conviction grew that this was a finished art, the beautiful souvenir of a life that was nearing its end. Sullivan decided quickly: his answer could not be found here. Less than a year after his arrival, he abandoned the delightful dream and returned to America.

To America and — by intuition or understanding or luck — to Chicago. The child with the passion to build chose the city in ruins. The choice was prophetic, for Chicago, of all cities, had not the time now, nor the inclination, to debate a building's style. Her first incredible growth had been destroyed by the fire, rebuilding had been hampered by a crippling depression. But now the pulse of industry revived; again came the unbridled ambition, the fiercely accelerating tempo. If Chicago in these years would accept the crude and the ugly and the makeshift, she would also accept the radical solution, the direct answer to her needs.

Sullivan spent five years of apprenticeship under several Chicago architects, perfecting his basic tools, learning from the common shoptalk of the older generation, from the tentative, intuitive experiments of the American bridgebuilder, from his read-

ings in science and history, from his secret, continuing dreams.

In 1879 the prospering, unknown, talented technician entered the office of D. Adler & Co. One year later — at the age of twenty-five — he became Adler's partner, and a full-fledged architect before the world. Now was his opportunity. Now the secret ambitions would be tested; slowly Sullivan developed the idea that had long been fermenting: that the dress of his new architecture would develop naturally and freely from the conditions that had called the building into being: that new forms would be discovered to praise new functions, that these forms would respond like plastic things to the needs and wants of purpose.

These were what came to be called (much later) the Brown Decades, and critics closer to our own time have wondered how any art of virtue could have been produced in the atmosphere of poetry-crushing materialism that accompanied our scrambling ascent to world power. America had more immediate problems than art. And when the new American leader, the industrial captain, did ask for art, to commemorate his battle or to celebrate his victory, what could this art be like? From what common heritage or common faith could this great and growing collection of free lances build a common art? So the American artist improvised, did the best he could, borrowed and adapted and adopted, and produced the jig-saw Gothic villa, and the brooding brownstone castle with a spiked iron fence for a moat, and the townhouse with the Renaissance façade recalling a bit of what Alberti had recalled from the ancients, and the swaggering Roman statehouse topped with a dome.

But now with this anarchistic variety behind us, in the day of a sweeter, mellowed materialism, we remember that those other disparaged days also produced the paintings of Thomas Eakins, and the Roeblings's Brooklyn Bridge, and the solid, integral buildings of Henry Hobson Richardson, and Whitman's *Leaves of Grass*, and that last great word of Victorian America, the Chicago Auditorium, by Dankmar Adler and Louis Sullivan.

There had been earlier buildings from that office, buildings that now seem tame enough, though Sullivan claimed that they labeled him an iconoclast to his colleagues. And iconoclast was probably the right word, for Sullivan had from the beginning chipped away at the overlay of inherited surface sentiment that "architecture," by and large, had been. But if his early works escaped the puerile rigidity of that day's architectural norm, it was in the Auditorium that Sullivan made his first great positive statement.

Here, in scale, was Sullivan's greatest problem, his most expansive opportunity. The giant stone monument, housing a business block and a hotel as well as the auditorium proper, was a problem of unprecedented complexity. Technical considerations alone presented a staggering problem. The mechanical equipment — the arteries and nerves and muscles and bowels of such a building — became more complex each week, as new devices were invented or demanded. Great buildings had always been formations of walls, walls forming rooms; now the telephone and the electric light and the elevator and central heating and modern plumbing had made a building a maze of intertwining conduits: conductors of people and light and heat and energy and water. Seven years before the Auditorium drawings were begun, Thomas Edison had found that bamboo was the material he needed for his incandescent light. When the Auditorium opened, it was lighted by ten thousand electric bulbs.

It was Dankmar Adler who solved the immense mechanical problem, and it was Adler's steadiness and confidence and judgment that bore the young Sullivan up in the recurrent crises that faced the building. But it was Sullivan's victory that the new technical problems were not merely met, but were welcomed as the basis for a new architectural expression. The electric light — no longer imitating a candle — was taken from the hanging chandelier and pushed directly into the richly ornamented walls and ceiling; the ornament itself became the lighting fixture, the room and its lights were made integral. The acoustical perfection of the great room was the result of Adler's intuitive engineering genius, but in the

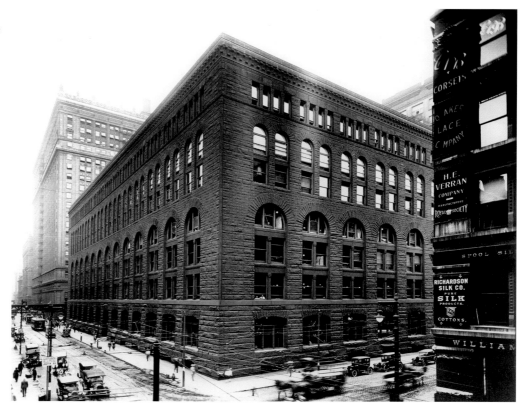

H. H. Richardson's
Marshall Field Warehouse

great concentric arches that expanded from the stage to the galleries Sullivan found visual expression for the fact, making the room read like the great hearing trumpet that it was.

In the design of the Auditorium's exterior Sullivan paid tribute to his great predecessor, H. H. Richardson. No inventor of basic architectural form, Richardson worked fundamentally in the grammar of the Romanesque, the form evolved by the master masons of medieval Europe. But to Richardson this style was not a veneer of book learning, for his own designs were conceived with the understanding of a master mason, where each stone states its weight and force, its role of support. In Richardson's work the art of architecture had been rejoined to the craft of building: the building's shell had again become the visible aspect of structure. But in the entrance of the Auditorium Hotel, and in the great theater itself, is the suggestion of a new thought: that a building is the void as well as the mass — that the solid material and the space enclosed are a single plastic reality. And the Auditorium Tower — a great structural tour de force, in itself surpassing previous efforts at tall of-

fice building construction — this tower was Sullivan's own. A new sense of scale and proportion show here, a new personality if not a new principle.

The Auditorium was an exhausting effort, three years of learning and inventing and sifting and reworking, of weighing the relative merits of conflicting functions, of finding what could at best be an imperfect integration of an omnibus problem. At the end Sullivan collapsed in utter weariness. Adler was denied that rest, as he watched the great tower settle, alert for the first sign of danger.

That sign never came, but the limit in height had been reached: since before the pyramids were constructed man had built his great permanent buildings by piling stone on stone, resting the weight of walls and floors on the walls below, down to a massive base. The Chicago Auditorium was among the last of these great masonry buildings. For the needs of the bridgebuilder had mothered the steel beam, which was bolted together in skeletal frames, to span great spaces. The architect and the land promoter quickly saw its uses, and in the same year that the Auditorium was completed, Major Jenney first hung

the walls of a building to a steel frame beneath. The sky was now the limit.

Then the Wainwright Building came to Sullivan's board. Quickly, almost effortlessly, with the simple, sure strokes of an encompassing understanding, Sullivan gave shape to the new principle of steel frame construction. He spoke of the spirit of loftiness, of an aspiring verticality, but the calm of equilibrium is in this building, and the nervous and sterile pylon that the skyscraper later became remembered more of Sullivan's words than of his work. For he had meant simply that the height of a tall building was no longer the sum of story piled on story, no longer additive, but integral, like the honeycomb of the bee, each cell forming a part of a larger cell.

Either the Auditorium or the Wainwright would have served as the triumphant climax of a great career. Sullivan was thirty-six, and if he had not built again his fame would have been secure. Now his personal horizons expanded. The roses and the garden paths of his new home in the Mississippi forests, on the shore of Biloxi Bay, now claimed much of his time. In the new offices in the Auditorium Tower thirty design draftsmen were busy. Adler and Sullivan had arrived. And with the great Richardson dead, who had better claim to his mantle than Louis Sullivan? "The Master's walk at this time bore dangerous resemblance to a strut," said the foreman of the thirty draftsmen, Frank Lloyd Wright.

The tall office building was the problem of the moment, and new commissions came to the office in the Auditorium Tower. Sullivan experimented, varied the basic formula according to specific conditions, strove for a richer statement. He traveled now, and watched his country, and thought and wrote of democracy and architecture; and in the busy offices he began to delegate much of the design burden. The young draftsman Frank Lloyd Wright found increasing opportunity to try his own hand. The apprentice was a hard master: why, he asked himself, should the plastic unity of statement belong only to the building's exterior, why could the interior space not "come through and button on the outside?" Tentatively, perhaps subconsciously, a new concept of ar-

chitectural design finds its way into Adler and Sullivan buildings. The idea suggested in the Auditorium entrance, the idea evolved and developed in the shorthand of Sullivan's ornament — where foreground and background dissolve in a fluid, integral third dimension — this idea appears more daringly in the Chicago Stock Exchange, where the roof hovers above the walls, where the walls seem not to touch at the corners, but hang free like faceted crystalline sheets.

In Sullivan's life, the place of Moses Woolson and John Edelmann had been filled by John Root, Sullivan's most gifted contemporary. Never intimate friends, the two were continually aware of each other's creative presence. Root, of Burnham and Root, was also designing progressive buildings, and now other firms followed close behind, experimenting on their own, quick to exploit the inventions of the leaders. In the common ground of new and native conditions, an American architecture seemed to be sinking roots.

Then came the Columbian Exposition of 1893, the

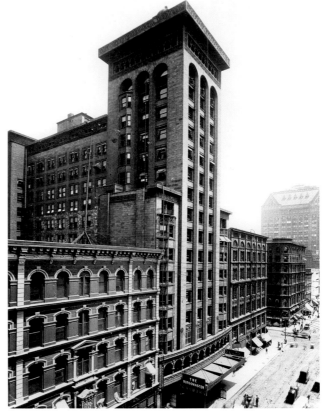

The Schiller (later Garrick) Theater, showing the cornice

greatest of American fairs.

In three years' time the architects of America planned and erected, on the mud bogs of Chicago's south side, a city from a fairy's dream. From lath and plaster, and magnificent energy and confidence, these men built a gleaming, white tribute to the architectural past, as they understood it. The Fair was cast in the scale that Chicago preferred: biggest. Its effect would have been impressive enough elsewhere, but in Chicago — in Chicago the Fair's oldest visitors could remember when a handful of Blackfeet Indians had destroyed what was then Fort Dearborn; and a boy could remember when the mud on which the city floats had run knee-deep through the streets — the effect was stupefying. As scene painting, as a backdrop for a pageant, the architecture of the Fair was an overwhelming success. *Such* a success that both architects and visitors forgot that this was make-believe, and overnight a new "classical" revival sprang into being. But this time it was not the plaything of esthetes and scholars, for this time the people themselves had seen grandeur, and had been impressed: they knew little of art, but they knew what they liked, and for forty years, and longer, they were to mimic the pasteboard elegance of the great Columbian Fair.

Or was the Fair less important than Sullivan thought? Was it really an imposition of the spurious from above, or simply the return to a normalcy which had never been seriously challenged? Had America been swindled of her right to art, or did she get exactly what she deserved? Had the brief ascendant moment of Chicago architecture really belonged to America, or only to the Great Fire, and to a moment when new questions were still unanswered? Were not the Imperial Roman masses of the Fair buildings a fitting symbol for the decade of Manifest Destiny?

Near one corner of the gleaming white city stood Sullivan's Transportation Building, gold and brown and green and crimson. Louis had conceived this building as a temporary pavilion, as true to its lath and plaster as the Auditorium had been to its mass of stone, a building to speak not of the glories of the architectural past, but of the thrill and the opportunities of the present. In its great golden beckoning doorway were impressed forty-seven distinct examples of Sullivan's original system of ornament. Each was an eloquent demonstration of the gulf that had opened between Sullivan and his colleagues.

Only four years after the completion of the Auditorium, Sullivan's rebellion was complete. He had cut himself off from the protection of professionalism, had dismissed as inadequate the forms of the past and the thinking of the present. As the forces of architectural reaction became stronger, his sharp tongue became sharper: ". . . and this man was a President of the American Institute of Architects, and he voiced this stupid, paltry sentiment in a presidential address . . ." (Serialized version of *Kindergarten Chats*, deleted in 1918 revision.)

Sullivan stood alone now on the horizon of his art. Not quite alone; the massive Adler still stood as balance wheel, as buffer between Sullivan and the client, the client who was most often attracted and held by the engineer's strong, quiet common sense.

After the Fair came the depression of 1893. Building slowed and ground to a standstill. In 1896 Adler withdrew from the partnership.

Not even the lyric poet can free himself completely from rules. After rejecting those of his generation, Sullivan began to evolve his own. He spoke of the rule so broad as to admit of no exception. He spoke of the building (or the ornament) as growing organically, unfolding from the procreant power of the germ idea. He said FORM FOLLOWS FUNCTION. But he also said: "The best of rules are but as flowers planted over the graves of prodigious impulses."

He said FORM FOLLOWS FUNCTION; and he spoke not of the functions of the sailing ship and the broad-bit ax, as had Horatio Greenough, but of the functions of the rosebud and the eagle's beak, and this seemed a different idea; for Greenough's "function" meant practical human use, plainly enough, but the function of the rosebud was to become a rose, and what was the practical use in that? He said

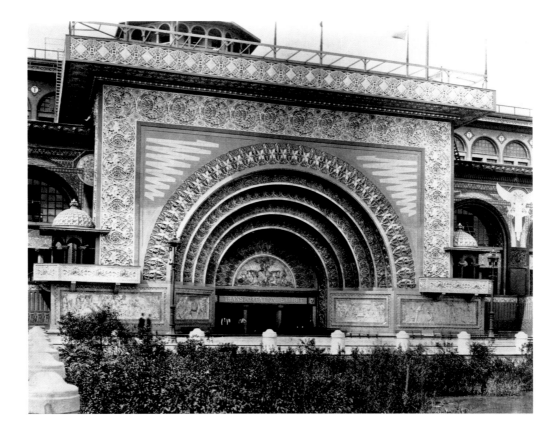

FOLLOWS, and this has caused trouble, but he also said that function and form were related, interwoven, intermeshed, interconnected, interblended; he spoke finally of their unison, where all was form, all was function.

It was necessary to understand and accept the fact that the form and the function of a building were interdependent, but this was not a solution for the designer — this gave him no basic values — for the rule held for the worst buildings as well as the best: "That which exists in spirit ever seeks and finds its visible counterpart in form, its visible image; an uncouth thought, an uncouth form; a thought in decadence, a form in decadence; a living thought, a living form." (*Kindergarten Chats*, p. 44.) So the problem for the artist and for his country was not first of all to express, but to *become*. The form would come hand in hand with the spirit, as the light with the rising sun.

Thus the pursuit of architectural values was the pursuit of life values, and the growth of an American building art could not far outstrip the growth of an American philosophy. And it had always been so.

The Greek had expressed in plastic art his discovery of his objective self and his love of the physically ordered; the Roman had praised in his buildings a new dimension in forceful power, the power of Emperor and engineer; the medieval builder had exalted Christ and his saints. Henry Adams, trying to understand the Columbian Exposition, wondered if the energies of modern technology could claim a people's love; the dynamo, perhaps, could replace the Virgin. And for many it did.

But the religion that Sullivan chose was the religion of Democracy. Democracy not as a constitution of laws, nor even as a theory of government by the governed, but as a Faith in man's impelling urge toward the unglimpsed summit of his humanity: toward self-accountability, self-knowledge, self-power. Such a Democracy could not come to a nation or a state; it could come only to the individual, for its essence was in the moral power of individual choice.

Through twenty-five years of frustration, humiliating defeat, and progressive poverty, Sullivan never lost his faith in man's desire to grow in moral stature. He said: "The lifting of the eyelids of the

world is what Democracy means." (*Autobiography of an Idea*, p. 279.)

Within a decade of Sullivan's death the formula "form follows function" was accepted by all but the most hardened Brahmins of the profession. But the symbols in the formula had been assigned new values, and *function* now stood for efficient heating and plumbing, and easy-to-clean surfaces. Or in its artistically more ambitious form, it meant luxury disguised behind puritanically plain surfaces. In 1938 George Elmslie, for many years Sullivan's assistant, wrote plaintively to the *Architectural Forum*. Sullivan, he said, would have found in the contemporary scene the same fatuous barrenness that he had found forty years earlier. "He would deplore the paralysing effect on normal creative impulses of literal interpretation of his 'Form follows Function' theorem.... To label as *good architecture* the spineless, dry as dust miscellany of pipes, windows and rounded corners, and call it *modern* is only an illustration of myotic understanding."

Today the formula has been changed once more, and function is now taken to mean not the need, the thing to be done, but the way of doing it. The architect is to find his salvation by expressing the true nature of the steel frame, or the ferroconcrete shell, or the welded joint, or the glass wall. And this, too, is a part of what Sullivan meant. But he would have warned that man's desire is the most basic of building materials, and that a framework for his psychic needs is the greatest structural problem. For the *function* of which Sullivan spoke was the spirit in search of substance. John had called it the Word.

Adler was gone now, and soon dead. John Root was dead, and his partner Daniel Burnham blushed at the follies of his headstrong youth, and bowed to the finer esthetic judgment of the ancients. The depression that followed the Fair had absorbed the inertia that the new architecture had assumed in the decade's first years. Louis did the Buffalo Guaranty (now Prudential) Building, secured while Adler was still in the office. Before the turn of the century came the New York Bayard (now Condict) Building, the

façade of the Gage Building in Chicago, and a sprinkling of smaller commissions.

There was still reason for Sullivan to hope that his reverses were temporary, for there was no lack of critical acclaim for the buildings that he did do. Montgomery Schuyler, the most perceptive critic of his day, declared that the architect who hoped to solve, rather than avoid, the problem of the skyscraper, must accept the Bayard Building as his point of departure: it was the prototype. Europe had discovered Sullivan through his Transportation Building at the Fair; it was indeed the only building to receive special recognition from the foreign visitors. In the following years models and photographs of Sullivan's work were exhibited in Europe, and the praise continued. Surely the obstinacy of the potential client, and of the profession at large, could not last.

In 1899, at the age of forty-two, Sullivan married. Among the objects of art with which he had surrounded himself, the ample and decorative Margaret must certainly have ranked high. And for a few brief years he was still able to exhibit her as she deserved. In 1903 he wrote to his agent in Mississippi: "Mrs. Sullivan . . . wishes you to secure, for her rental and use, a stylish 'spiderphaeton,' to seat two persons...."

Then in 1900 came the Schlesinger-Meyer (now Carson Pirie Scott) Department Store. Here was a radically new problem. In the tall office building the unit had been the individual cell, a near-cube. It was from the vertical extension of these cells that the design derived its vertical emphasis. But the department store demanded continuous, uninterrupted floor space; the unit was now the whole story, and the building a series of tiers. By broadening the window and emphasizing the horizontal girder rather than the vertical column, Sullivan found an exterior expression for the reality of the space within.

Incredibly, this masterwork attracted no further important commissions. Was the work too radical for Chicago's 1900 taste? Perhaps; more likely it seemed old-fashioned, for its cleanly divided façades and its rich and original ornament had more in common with the building of Chicago's nineties than with the

new fashion of historical tableaux. The new ideal of architectural beauty was the collage from the copybook, and the fashionable architect collected cornices and column capitals and lintels and mantelpieces and decorative frets, and composed these elements, nicely or clumsily, on whatever bones his structural engineer had given him.

When an additional section was added to the Carson Pirie Scott store in 1904, the contract was awarded to Daniel Burnham, although the four bays he added followed the original Sullivan design. Sullivan's financial troubles became more acute, and there were few Chicago architects to grieve that the superior, trouble-making, cocksure radical was getting his comeuppance. In 1909 Sullivan's property, his library, and his valuable collection of Oriental art were sold at auction.

The theater, the office building, the department store: on each of these Sullivan left the lasting imprint of his genius. In 1907 came Sullivan's last new problem: the country bank. Forgotten and discredited in the cities that he helped shape, the archi-

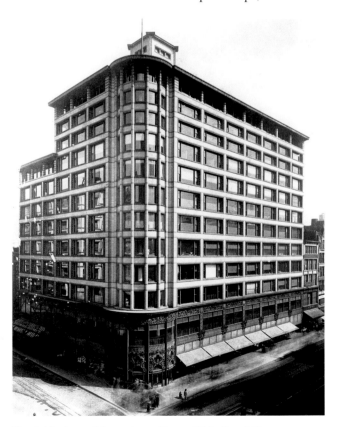

The Schlesinger-Meyer (now Carson Pirie Scott) Department Store, showing the cornice

tect found his greatest client in Gopher Prairie. One year earlier Sullivan had written: "This flow of building we call Historical Architecture. At no time and in no instance has it been other than an index of the flow of the thought of the people . . . an emanation from the inmost life of the people . . ." (*What Is Architecture?* p. 228.)

Carl Bennett, president of the National Farmers Bank at Owatonna, Minnesota, read this, and found the master builder to clarify and express his vague desire for a business place in harmony with the fertile countryside, the independence, the working democracy of this American place, fifty years from the frontier.

This building has become a monument of modern architecture, yet its stone and baked clay and bronze were ancient materials to the Romans who perfected its arch and its stained glass. From the basic alphabet of ancient construction, Sullivan fashioned a prototype — a new spirit of beauty in man's works. The germ idea is the vault, the secured interior space, and it is the freedom and the strength of the *inside* that reaches through the massive walls and shows itself to the street. The great soaring arch is in equilibrium with the downward masonry thrust: the opening is not now *in* but *of* the wall, like the mouth of the potter's vase. Here, as in the Getty Tomb earlier, is the perfect music of architecture fully achieved.

As Sullivan worked less he drank more; finally Margaret despaired, admitting her inability to cope with the man and his way of tempering the desperation of idleness. In 1907 she left, without protest or bitterness from Sullivan.

Sullivan's permanent staff had shrunk to a single man, George Elmslie, who had come twenty years before as the assistant of Frank Lloyd Wright. Elmslie too had become an able pencil in the Master's hand, and in the later years Sullivan had leaned heavily on his skill and understanding. Now, with no work in the office and none in prospect, Elmslie begged permission to leave. In the same year Sullivan was forced to give up the empty offices in the Auditorium Tower, from which he had for so long watched the great

Lake in her infinite moods.

The Chicago Auditorium was then twenty years old. Sullivan was fifty-three. He would die at sixty-eight, and in the remaining years there would be seven country banks, a residence, a drawing for a small store façade. Flashes of a former greatness illumine these works, but the radical was really small threat now; inactivity and loneliness and alcohol and finally hunger — and most of all the anguish of longing — had diluted his power.

But his cutting tongue did not fail him, and this offered some comfort as he saw his life run out, and his work forgotten. And (except for brief, bitter moments) he held his faith in the ultimate beauty of his people.

For, my lad, beauty has not really departed from the sons of earth.

Nor is high thinking but a memory of days gone.

Nor is the winsome art of saying done for.

Nor has the power of man forsaken him.

If he has lost them, on his way, he has but to call to them:

They will answer and come gladly.

His spirit will revive.

(*Kindergarten Chats*, p. 161.)

THE CITY

This indeed is an architecture well worth the studying; for its like does not exist elsewhere on earth. It is a product of the time, of the place and of the men; and the time, place, men and architecture are all alike. The barbaric variety, the unrest, the ignorance, the vulgarity, the scholarship, the culture, the yard-stick architecture, the blind-man's architecture, the deaf-man's architecture, the lame-man's architecture, each gives out its raucous individual note, and all together swell and sway and swirl into a huge monotone of desolation, of heartlessness, and of an incredibly arid banality that roars above a muffled murmur of incompetence and strangulation.

Here indeed is an architecture to be studied! For the roar of the streets is not louder than the roar of what lines the streets — a quarreling herd, ranging mile after mile, pressing hard, shoulder to shoulder, tied hands, tied feet, leering and howling at the passer, or smirking and winking and giggling. Oh, this hocus-pocus, does it not sicken one in his heart!

LOUIS SULLIVAN, *Kindergarten Chats*

I

END AND A BEGINNING

. . . These things are important; because they occurred during the period of the great hinge, when the art and especially the architecture of the world — under the pressure of Louis Sullivan, under the direction of Frank Lloyd Wright, and helped as might be by a few of the rest of us — turned a full ninety degrees and headed in another direction: something that had never happened in the world before in just that way. It seems to me that the flowering, if we can call it that, or the bursting (which is more likely the right word) of the machine age cut the development of man into two great areas — everything that happened before roughly 1892, and everything that has happened and is going to happen since that time.

WILLIAM GRAY PURCELL, architect

I have heard what the talkers were talking the talk of
the beginning and the end.
But I do not talk of the beginning or the end.

There never was any more inception than there is now,
Nor any more youth or age than there is now,
And will never be any more perfection than there is now,
Nor any more heaven or hell than there is now.

Urge and urge and urge,
Always the procreant urge of the world.

Sure as the most certain sure, plumb in the uprights,
well entretied, braced in the beams,
Stout as a horse, affectionate, haughty, electrical,
I and this mystery here we stand.

WALT WHITMAN, *Song of Myself*

1887: AN OASIS

THE MASTER: Let us pause, my son, at this oasis in our desert. Let us rest awhile beneath its cool and satisfying calm, and drink a little at this wayside spring.

For, when we fret amid the barren wastes of meanness and of littleness of soul, wherefrom arise strident, harsh and paltry sounds, a rich, sombre chord of manliness, as this is, comes the more awelcome, since we have, as yet, afar to go, 'cross many weary stretches.

THE STUDENT: You mean, I suppose, that here is a good piece of architecture for me to look at — and I quite agree with you.

THE MASTER: No; I mean, here is a *man* for you to look at. A man that walks on two legs instead of four, has active muscles, heart, lungs and other viscera; a virile force — broad, vigorous and with a whelm of energy — an entire male.

I mean that stone and mortar, here, spring into life, and are no more material and sordid things, but, as it were, become the very diapason of a mind rich-stored with harmony.

I mean that —

THE STUDENT: I see; you mean that it's simple, dignified and massive.

THE MASTER: I mean, just now, that you are assive, priggified and a simpleton.

THE STUDENT: But I see defects in it —

THE MASTER: And I see your eye has a mote in it. In Heaven's name, what defects are you justified in seeing in so fine a work? Do you put yourself in the scales with a mountain?

THE STUDENT: But truly, has it not defects?

THE MASTER: Forsooth it has. And so has the bark of an ancient tree; and so has the bark of an ancient dog, if you will: but the faithfulness is there, the breath of life is there, an elemental urge is there, a benign friendliness is there. Would you peck at the features of the moon, and ignore her gracious light that makes a path for you in the forest? Go to, my young friend, go to!

LOUIS SULLIVAN, *Kindergarten Chats*

OPPOSITE AND PAGES 35–55: The Chicago Auditorium, 1886–89

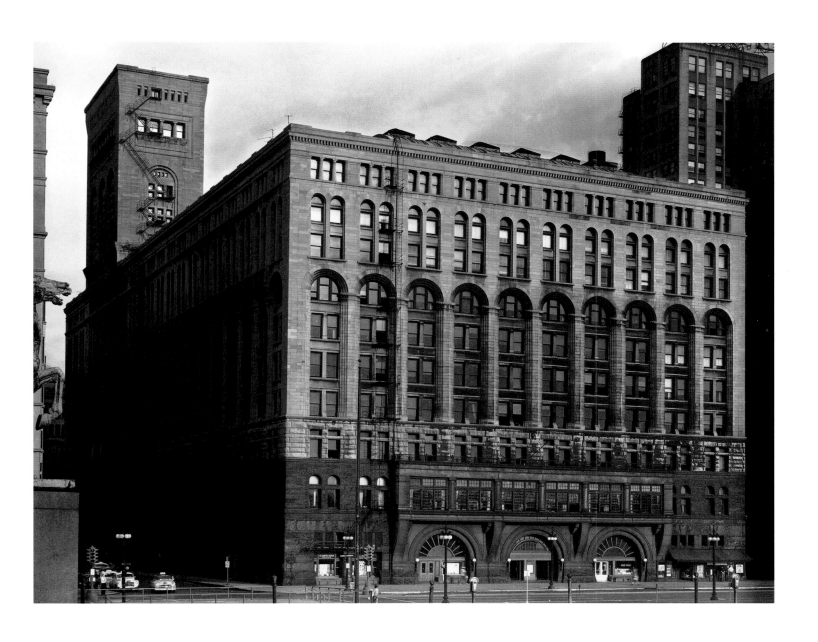

CHICAGO: MAKE NO LITTLE PLANS

Said Mr. Armour to Mr. Onahan; "what is this I see in the papers about the Pope? Do you think the Pope will leave Rome? Where do you think the Pope is going to?"

Mr. Onahan said he did not know that the Pope would go anywhere, but if the revolution broke out in Italy he might be compelled to take refuge with some friendly power.

"Why should he not come to Chicago?" said Mr. Armour.

Mr. Onahan continued his story. "I explained to Mr. Armour," he said, "that the Pope was not a mere individual, but he was a spiritual sovereign with departments of state, and that it would be impossible for him to transfer himself to Chicago as easily as if he were a Cook's tourist. He would require great administration buildings."

"I don't see that that makes any difference," said Mr. Armour. "It is all a question of money, is it not? Why could we not form a syndicate, some of us, and take up a large plot of land, as large as you like, and put up buildings, and make everything ready for the Pope so that he could come and settle here with all his Cardinals and congregations; and then," said Mr. Armour , with a twinkle in his eye, "we should make more money by selling what was left of the land than we spent in buying the original tract."

WILLIAM T. STEAD, *If Christ Came to Chicago*

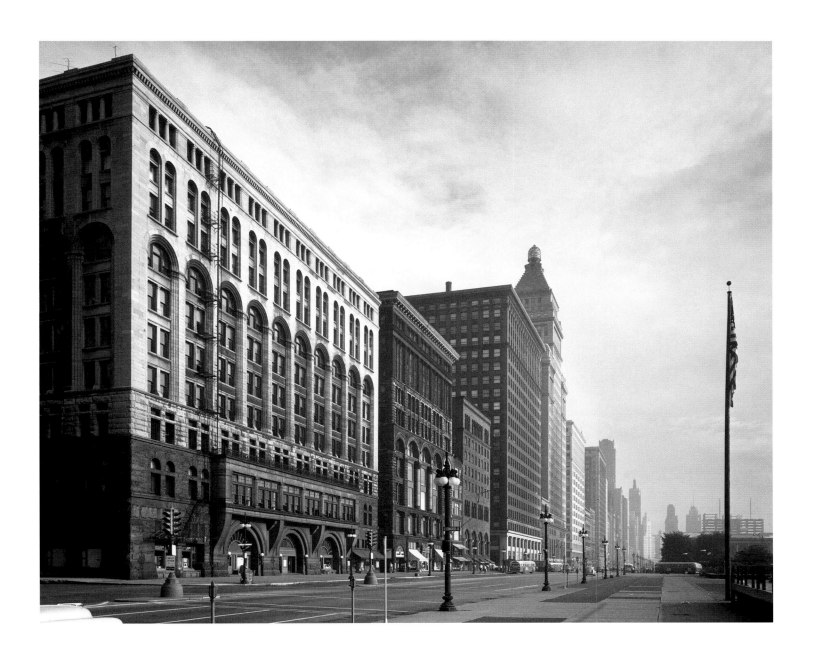

For several years there had been talk to the effect that Chicago needed a grand opera house.

In 1885 there appeared the man of the hour, Ferdinand W. Peck, who declared himself a citizen, with firm belief in democracy — whatever he meant by that; seemingly he meant the "peepul." At any rate, he wished to give birth to a great hall within which the multitude might gather for all sorts of purposes including grand opera; and there were to be a few boxes for the *haut monde.*

Peck, the dreamer for the populace, sought Adler, the man of common sense.

For four long years Dankmar Adler and his partner labored on this enormous, unprecedented work.

Louis's heart went into this structure. It is old-time now, but its tower holds its head in the air, as a tower should.

<div align="right">Louis Sullivan, The Autobiography of an Idea</div>

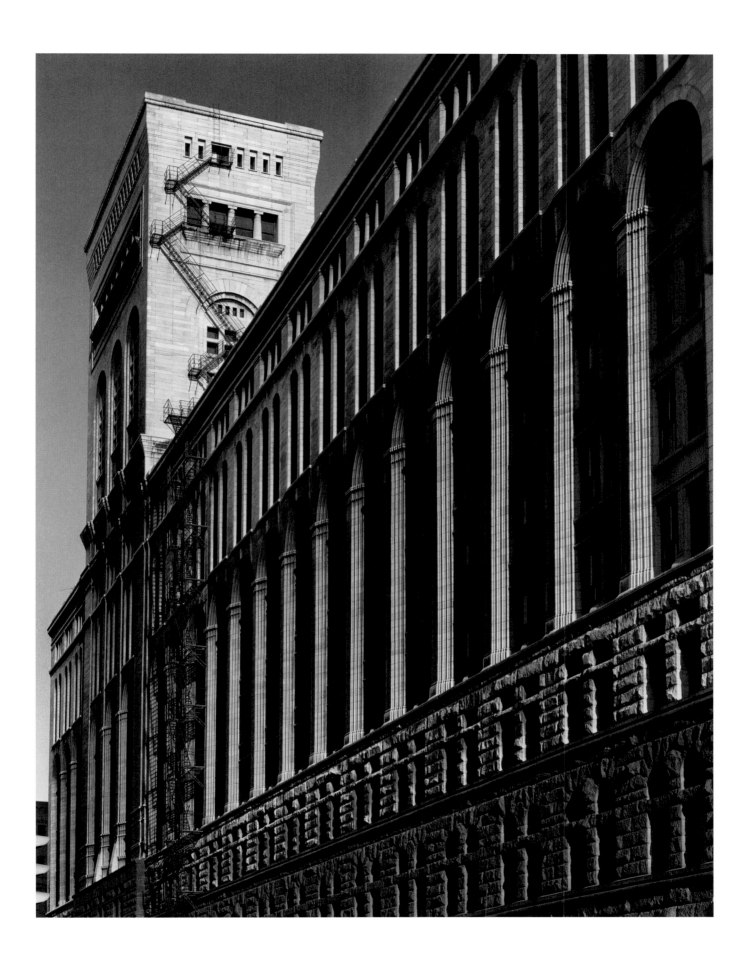

A great engineer came to mind — I saw him, as was his wont, walking the floor. His shaggy head, beetling brows over deep set eyes, lowered in anxiety. The great tower of the Auditorium building had begun perceptibly to go down and take the adjoining structure with it. Two more stories added to that solid masonry tower had cut down the "factor of safety" after the footings were already in, a chance Dankmar Adler took to please Louis Sullivan and, be it said, as he himself knew, improve the scheme as a whole.

For eleven years the inexorable movement, gradual as a glacial drift, continued and the patching of plaster inside was kept up. The sidewalk in front of the tower had twice to be raised. And the brilliant throngs all these years would pass in and out in evening dress concerned only with the gaiety of the occasion, taking all for granted.

All that could be done was to wait, to watch, and, if necessary, give warning in time.

Always I sat there with perfect faith in him. It may be that at no time was there immediate danger of collapse any more than now that the movement has finally ceased. But I knew what the master-builder, if ever there was one, was suffering. It killed him twenty years before his time, I think.

FRANK LLOYD WRIGHT, *An Autobiography*

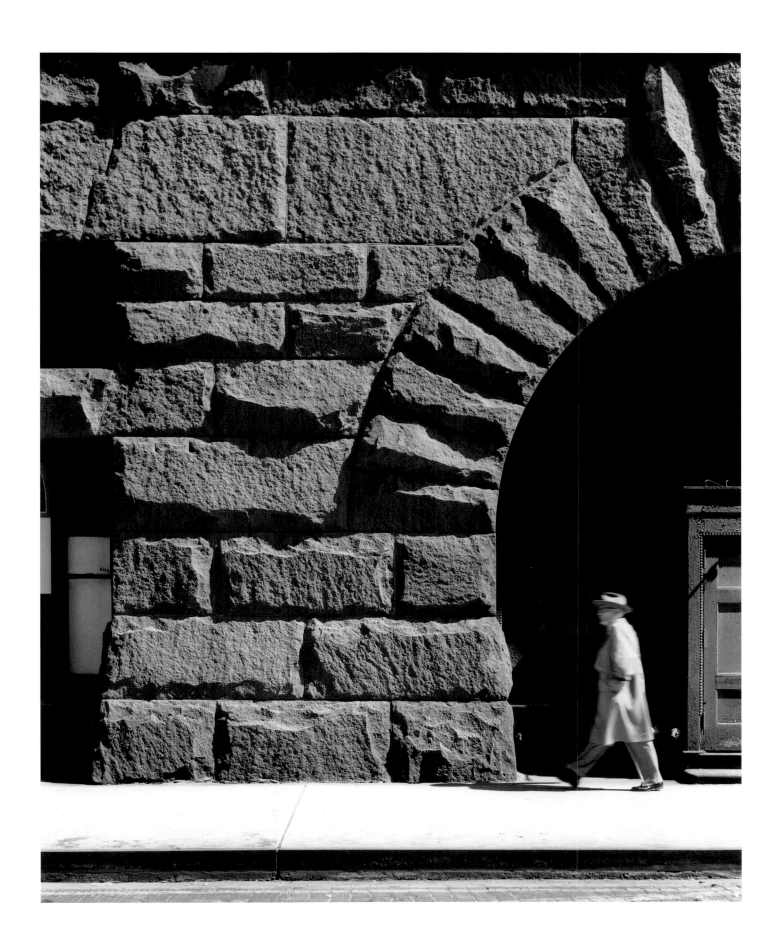

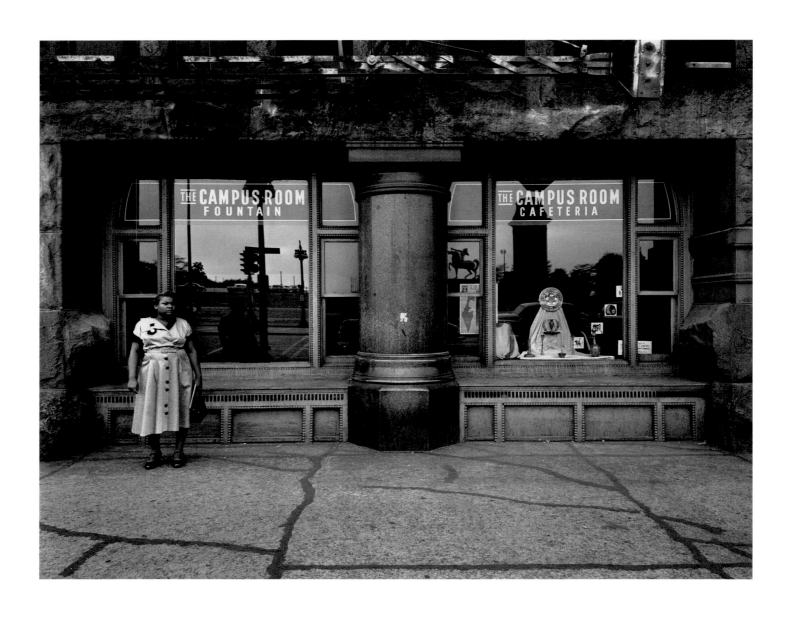

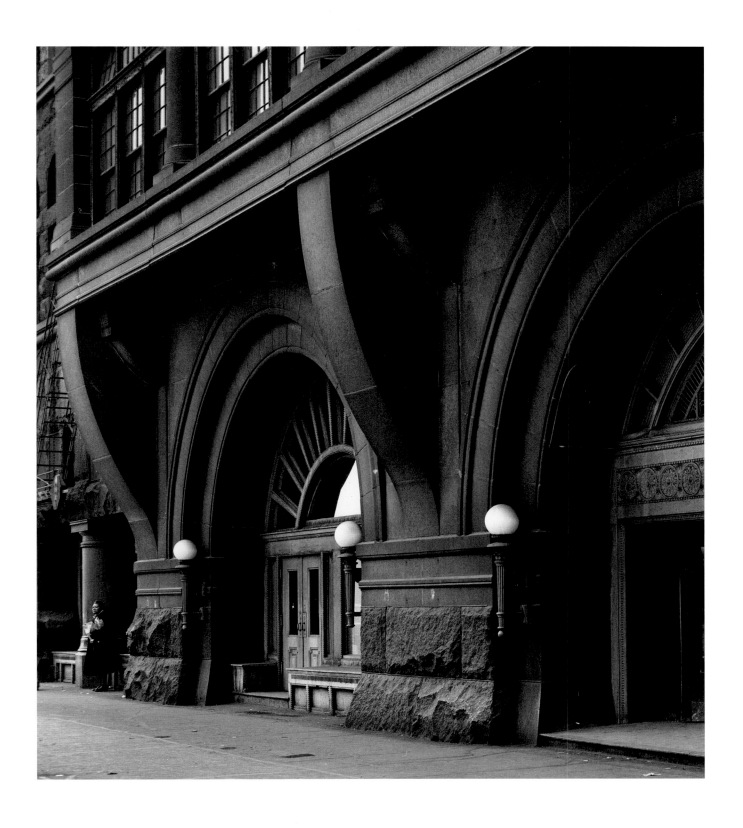

CHICAGO AND THE HIGHER CULTURE

THE NEW YORK WORLD, April 9, 1893:

Ward McAllister has given careful attention to the question of how New York society will be treated in Chicago during the World's Fair. He is disposed to think that fashionable persons in this city need not fear anything but the best treatment at the hands of Chicagoans.

He said yesterday:

"There are really a great many fine people in Chicago. New York Society has hardly a proper conception of what Chicago is. A number of our young men are already beginning to make investigations as to the wealth and beauty of the Chicago women with the result that they are now more anxious to go to the Fair than ever.

"The fact that a man has been brought up in the West does not mean that he is not capable of becoming a society man. I could name over many men and women who have been forced to spend a large part of their early life in the West, but who have nevertheless established themselves in a good position in Eastern Society.

"I see that the newly elected Mayor of Chicago has announced that visitors to the Fair need not fear a lack of hospitality. It may be a little rough, he said, but it will be genuine. In reply to this I may say that it is not Quantity but quality that the society people here want. Hospitality that includes the whole human race is not desirable.

"I should suggest that the Chicago society import a number of fine French Chefs. I should also advise that they do not frappé their wine too much."

THE CHICAGO JOURNAL, April 12, 1893:

The Mayor will not frappé his wine too much. He will frappé it just enough so the guests can blow the foam off the tops of the glasses without a vulgar exhibition of lung and lip power. His ham sandwiches, sinkers, and Irish Quail, better known in the Bridgeport vernacular as pigs' feet, will be triumphs of the gastronomic art.

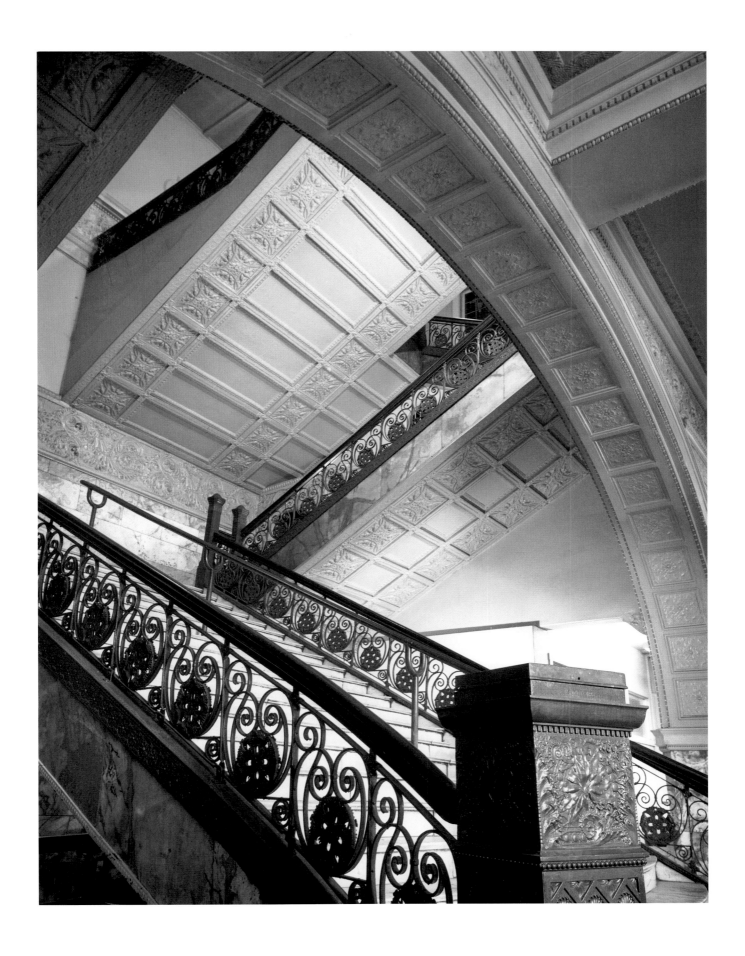

THE NEW YORK WORLD, April 15, 1893:

In another interview yesterday, Mr. McAllister has endeavored to make himself more clear:

"The leaders of society in the Windy City, I am told, are the successful pork-packers, stockyard magnates, cottolene manufacturers, soapmakers, Chicago gas trust manipulators, and dry goods princes. These gentlemen are undoubtedly great in their way, but perhaps in some cases unfamiliar with the niceties of life and difficult points of etiquette.

"It takes nearly a lifetime to educate a man how to live. Therefore Chicagoans can't expect to obtain social knowledge without experience and contact with those who have made such things the study of their lives. In these modern days society cannot get along without French Chefs. The man who has been accustomed to delicate fillets of beef, terrapin, pate de foie gras, truffled turkey, and things of that sort, would not care to sit down to a boiled leg of mutton with turnips."

April 23:

"I have never called Chicago a pork-packing town nor a vulgar town. In regard to Chicagoans coming here to get points like gaping natives, which Mrs. Sherwood says they do not, I may say that it is never too late to learn."

THE CHICAGO TIMES, April 18, 1893 (one of a list of questions to be asked of those seeking high social position:)

"Do you consider Ward McAllister a great man, a simple poseur, or an ordinary every day matter-of-fact damn fool?"

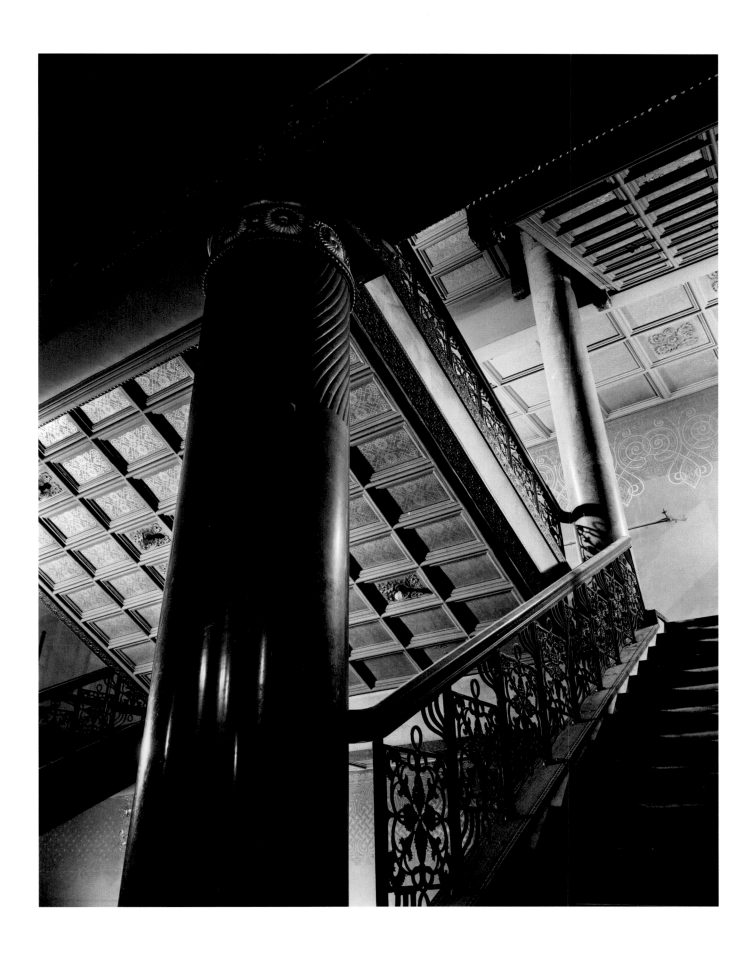

This, then, is the real situation: A people composed of heterogeneous materials, with diverse and conflicting ideals and social interests, having passed from the task of filling up the vacant spaces of the continent, is now thrown back upon itself, and is seeking an equilibrium. The diverse elements are being fused into national unity. The forces of reorganization are turbulent and the nation seems like a witches' kettle.

The Old Northwest holds the balance of power, and is the battlefield on which these issues of American development are to be settled. It has more in common with all parts of the nation than has any other region. It understands the East, as the East does not understand the West.

In the long run the "Center of the Republic" may be trusted to strike a wise balance between the contending ideals. But she does not deceive herself; she knows that the problem of the West means nothing less than the problem of working out original social ideals and social adjustments for the American nation.

FREDERICK JACKSON TURNER, *The Frontier in American History*

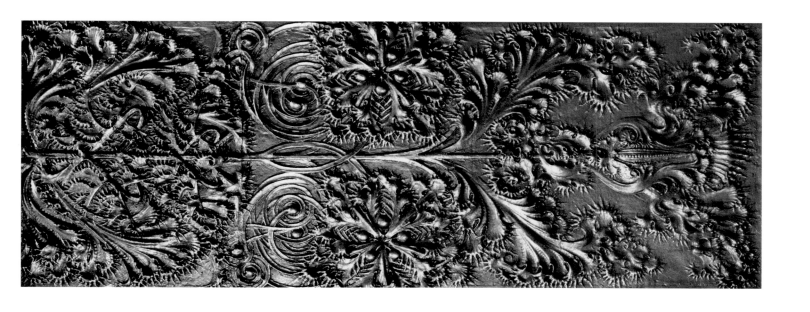

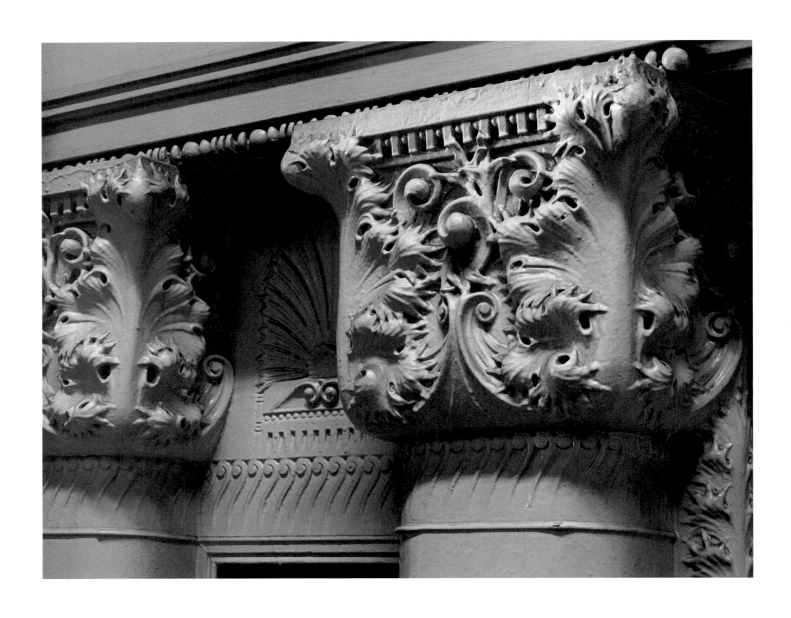

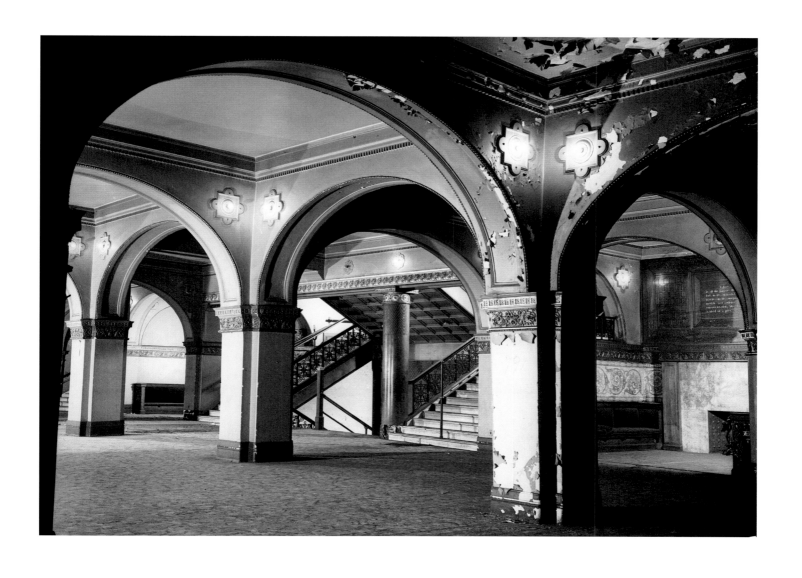

1889

THE NEW SPIRIT HAS TRIUMPHANTLY ASSERTED ITSELF IN THE AUDITORIUM, WHICH IS THE MOST SPLENDID TRIBUTE TO THE GENIUS OF ART ON THE AMERICAN CONTINENT. IT IS NOT A TEMPORARY AFFAIR; IT WAS BUILDED TO THE AGES, AND IT WILL ENDURE WITH THE NATION, AND ONLY FALL INTO RUIN WHEN THE GREAT PRINCIPLES UPON WHICH THIS GOVERNMENT IS BASED HAVE BEEN OVERWHELMED BY THE FOLLY AND DEGENERACY OF MEN.

Editorial in *The Chicago Daily Inter-Ocean,* September 10, 1889

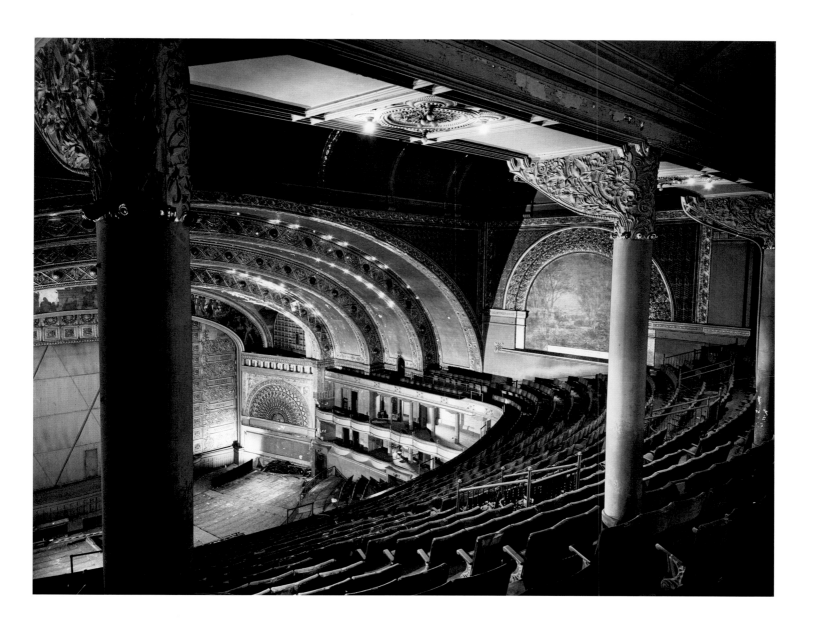

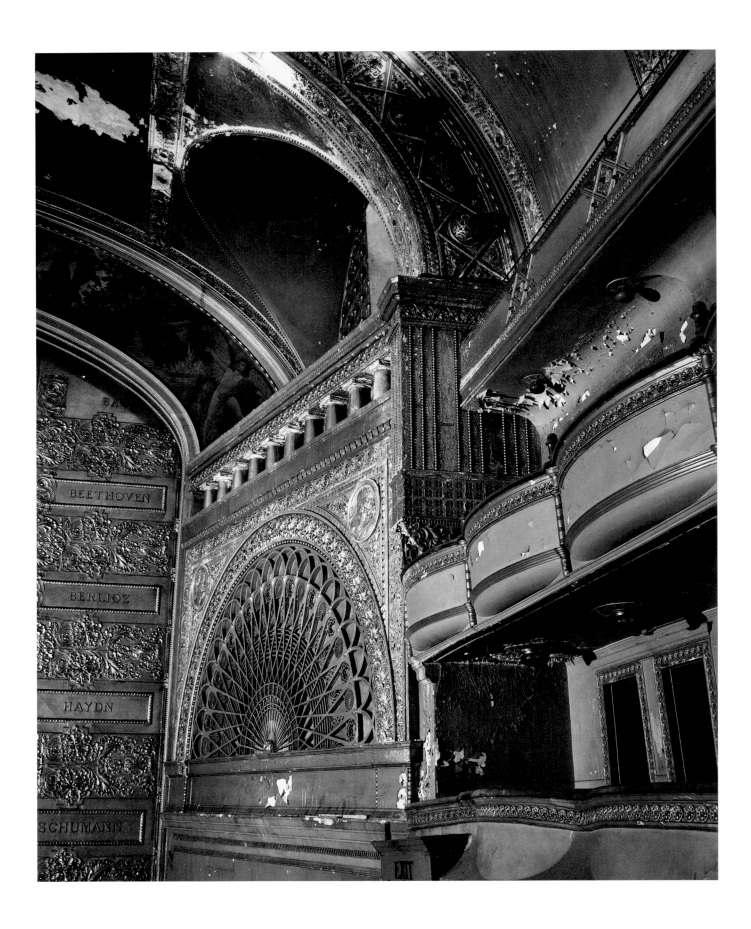

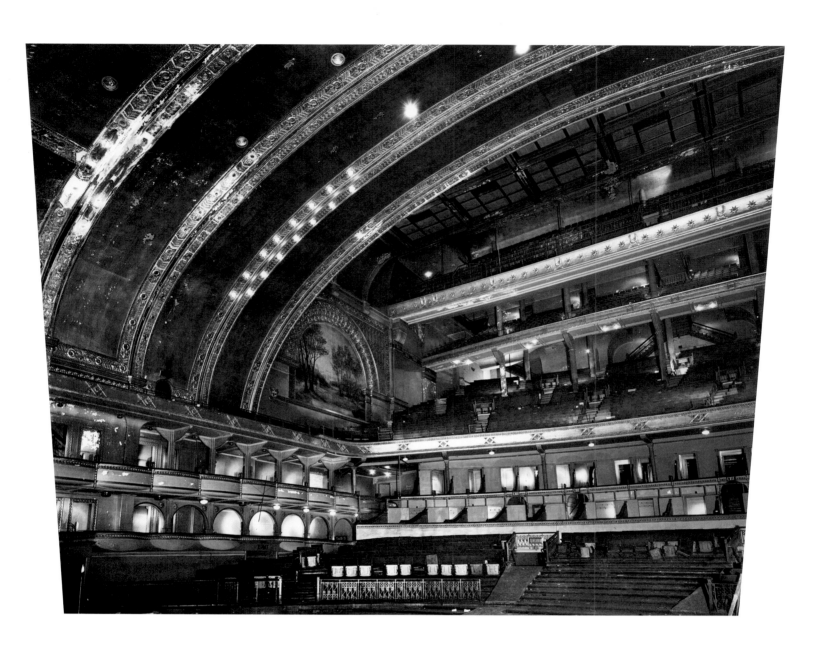

1927

The venerated Auditorium, soaked in the memories of thirty-seven years of the finest music in the world, must sooner or later be given up.

"Our present lease of this house ends next September," Mr. Insull said. "We can get a renewal of the lease for a few years. This block of buildings ultimately will be torn down, and we are faced with the absolute necessity of moving if we want to preserve our organization."

"[The new building] cannot be purely monumental," he added. "It must be commercial, not only self-supporting, but profitable."

The Chicago Tribune, January 29, 1927

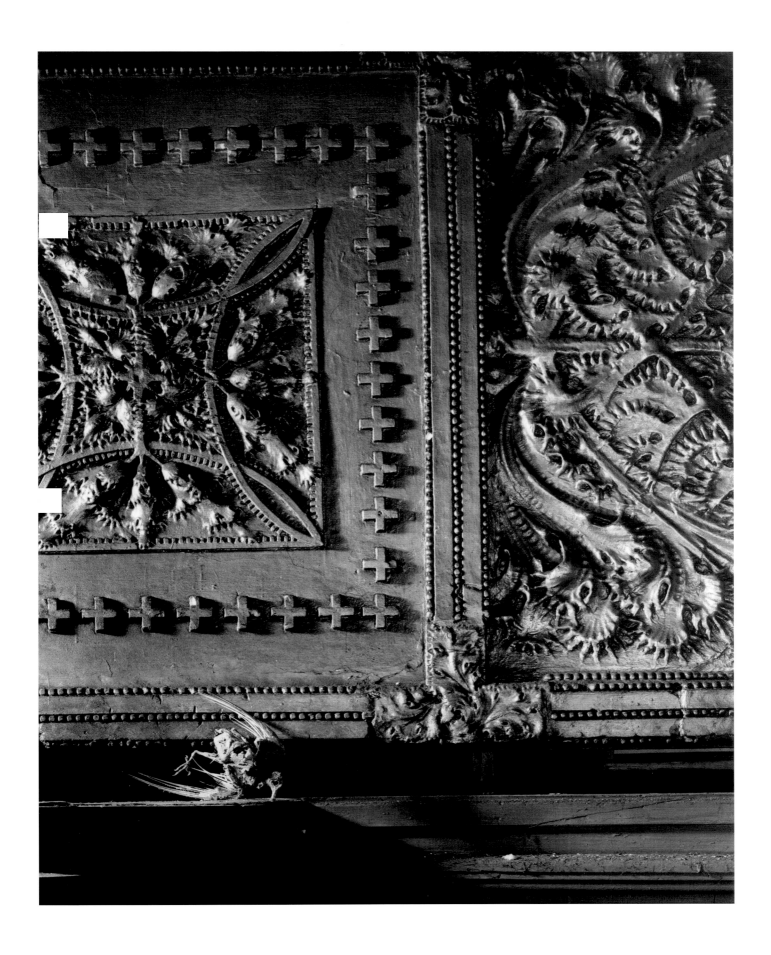

II

STEEL, ART, AND THE ENGINEER

The most strictly scientific of constructors looks upon the current architectural devices as frivolous and irrelevant to the work upon which he is engaged, and consoles himself for his ignorance of them by contempt. Architecture is to him the unintelligent use of building material. Assuredly his view is borne out by the majority of the "architecturesque" buildings that he sees, and he does not lack express authority for it: Whereas the engineer's definition of good masonry is "the least material that will perform a certain duty," Mr. Ferguson declares that "an architect ought always to allow himself such a margin of strength that he may disregard or play with his construction"; and Mr. Ruskin defines architecture to be the addition to a building of unnecessary features.

But if we go back to the time when engineers were artists, and study what a modern scientific writer has called "that paragon of constructive skill, a pointed cathedral," we shall find that *the architecture and the construction cannot be disjoined.* The work of the medieval builder in his capacity of artist was to expound, emphasize and refine upon the work that he did in his capacity of constructor, and to develop and heighten its inherent effect. And it is of this kind of skill that the work of the modern engineer, *in so far as he is only an engineer,* shows no trace.

MONTGOMERY SCHUYLER, *American Architecture*

Louis found himself drifting toward the engineering point of view, as he began to discern that the engineers were the only men who could face a problem squarely; who knew a problem when they saw it. Their minds were trained to deal with real things, as far as they knew them, while the architectural mind lacked this directness, this singleness of purpose. The trouble as he saw it was this: That the architect could not or would not understand the real working of the engineering mind because it was hidden in deadly literal attitude and results, because of the horrors it had brought forth as misbegotten stigmata; while the engineer regarded the architect as a frivolous person of small rule-of-thumb consequence. And both were largely right; both professions contained small and large minds — mostly small or medium.

LOUIS SULLIVAN, *The Autobiography of an Idea*

About this time two great engineering works were under way. One, the great triple arch bridge to cross the Mississippi at St. Louis, Capt. Eades, chief engineer; the other, the great cantilever bridge which was to cross the Chasm of the Kentucky River, C. Shaler Smith, chief engineer. In these two growing structures Louis's soul became immersed. In them he lived. Were they not his bridges? Surely they were his bridges. In the pages of the *Railway Gazette* he saw them born, he watched them grow. Week by week he grew with them. Every difficulty encountered he felt to be his own; every expedient, every device, he shared in. The chief engineers became his heroes; they loomed above other men.

LOUIS SULLIVAN, *The Autobiography of an Idea*

OPPOSITE: The Eades Bridge, St. Louis, finished in 1874

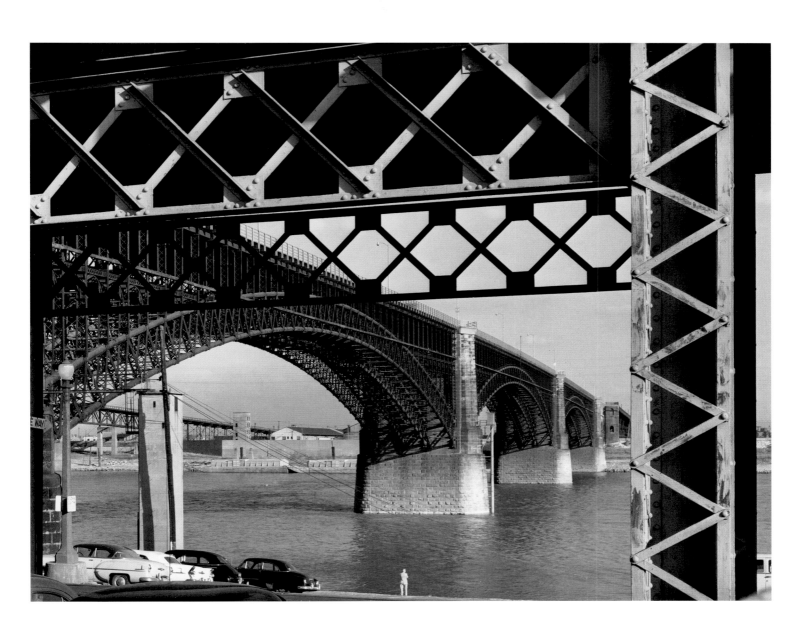

1890: REVOLUTION

Important work was at hand in other cities as well as in Chicago. The steel-frame form of construction had come into use. It was first applied by Holabird & Roche in the Tacoma Office Building, Chicago; and in St. Louis, it was first given authentic recognition and expression in the exterior treatment of the Wainwright Building, a nine-story office structure, by Louis Sullivan's own hand. He felt at once that the new form of engineering was revolutionary, demanding an equally revolutionary architectural mode. That masonry construction, in so far as tall buildings were concerned, was a thing of the past, to be forgotten, that the mind might be free to face and solve new problems in functional forms. That the old ideas of superimposition must give way before the sense of vertical continuity.

LOUIS SULLIVAN, *The Autobiography of an Idea*

OPPOSITE AND PAGES 62–71: The Wainwright Building, St. Louis, 1890

THE MASTER: Let us pause before this object, this subject, this it; let us pause, and wonder. I say, it, because it is neuter. The masculine implies that which is virile, forceful, direct; the feminine: intuitive sympathy, tact, suavity, and grace. But this it! This droll and fantastical parody upon logic; this finical mass of difficulties; this web of contradictions; this blatant fallacy; this repellent and indurated mass; this canker on the tongue of natural speech!

Is there no sane tribunal on earth? It must be that the people below are too busy — too busy to think, too patient to care, too nonchalant to trouble, too sordid to see, and too ignorant to smile. That must be why, in this instance, as in many another, the people are successfully flouted and damned, and not the building.

<div align="right">LOUIS SULLIVAN, Kindergarten Chats</div>

When he brought the drawing board with the motive for the Wainwright outlined in profile and elevation upon it and threw the board down on my table I was perfectly aware of what had happened.

This was a great Louis H. Sullivan moment. The tall building was born tall. His greatest effort? No. But here was the "skyscraper": a new thing beneath the sun, entity imperfect, but with virtue, individuality, beauty all its own. Until Louis Sullivan showed the way, high buildings lacked unity. They were built-up in layers. All were fighting height instead of gracefully and honestly accepting it. What unity those false masonry masses have that now pile up toward the big city skies is due to the master mind that first perceived the high building as a harmonious unit — its height triumphant.

FRANK LLOYD WRIGHT, *Genius and Mobocracy*

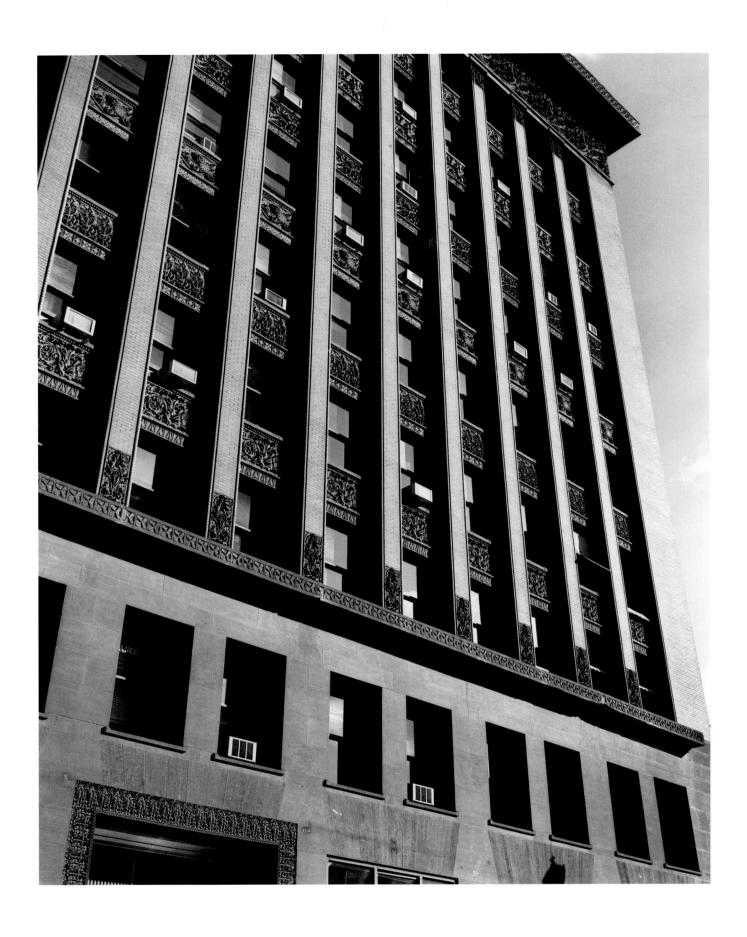

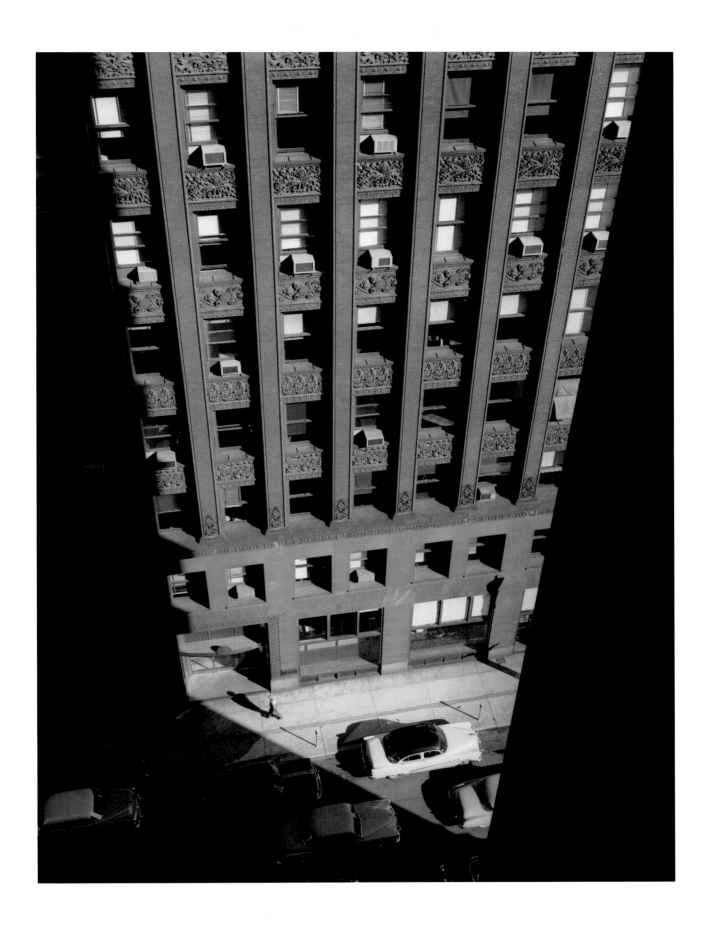

Now, I can at best tell you only what may be transmitted by the spoken word, *but if your imagination does not grasp and receive what I mean, I fail.* I cannot convey to you in words the bloom on a fruit — you must see it to know it. I cannot depict to you in words the melody of a bird's song — you must hear it to know it. I may have seen the bloom and heard the song, but I cannot convey their reality to you. I can only suggest. To know them you must hear and see for yourself. By your living power you must absorb them.

Louis Sullivan, *Kindergarten Chats*

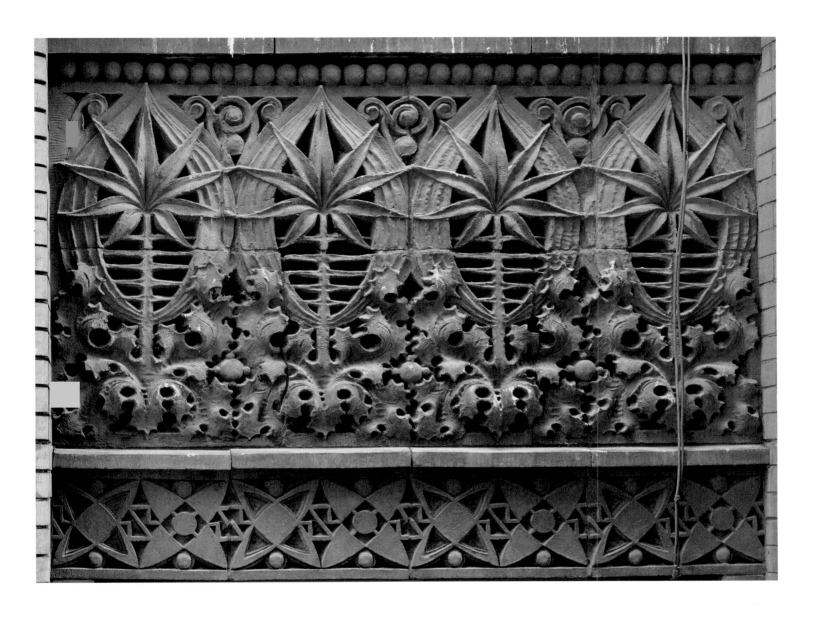

The Wainwright went very far — a splendid performance on the record for all time. Although the frontal divisions were still artificial, they were at least, and at last, effective. But the flat roof-slab overhung the street, you say? Well, you may also say that these frontal divisions were no less eclecticisms for being fresh. But a new countenance had come to light! The picturesque verticality with which he did emphasize its heights, although appropriate, was still a mere façade. Where and how was the actual nature of this building construction? Equivocation in this respect by the Wainwright. Yes, but far less than in most contemporary building effort. This revolt and departure from the insignificant academicisms of that day wore a genuinely fresh countenance and was prophetic if not profound.

In his vision, here beyond doubt, was the dawn of a new day in skyscraper architecture.

But other lifetimes yet to come would have to be expended upon the task of making the countenance of building authentic of structure — in order to finally make that countenance of construction integral: innate architecture.

FRANK LLOYD WRIGHT, *Genius and the Mobocracy*

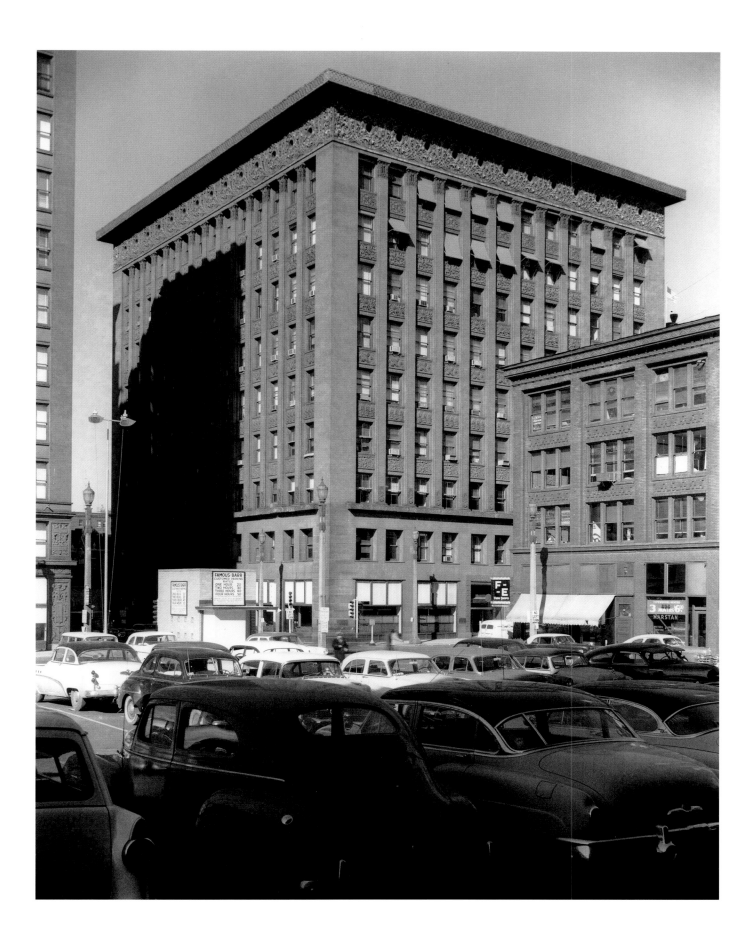

III

THE SKYSCRAPER AND THE CITY

Let us state the conditions in the plainest manner. Briefly, they are these: offices are necessary for the transaction of business; the invention and perfection of the high-speed elevators make vertical travel, that was once tedious and painful, now easy and comfortable; development of steel manufacture has shown the way to safe, rigid, economical constructions rising to a great height; continued growth of population in the great cities, consequent congestion of centers and rise in value of ground, stimulate an increase in number of stories; these successfully piled one upon another, react on ground values — and so on, by action and reaction, interaction and inter-reaction. Thus has come about that form of lofty construction called the "modern office building." It has come in answer to a call, for in it a new grouping of social conditions has found a habitation and a name.

LOUIS SULLIVAN, *The Tall Office Building Artistically Considered* (1896)

A man in a congested downtown New York street, not long ago, pointed to a vacant city lot where steam shovels were excavating. "I own it," he said, in answer to a question to a man next to him (the man happened to be me), "and I own it clear all the way up," making an upward gesture with his hand. Yes, there stood His Majesty, legal ownership. Not only was he legally free to sell his lucky lot in the landlord lottery to increase this congestion of his neighbors "all the way up," but he was blindly encouraged by the great city itself to do so, in favor of super-concentration.

Space-makers-for-rent say skyscrapers solve the problem of congestion, and might honestly add, create congestion, in order to solve it some more some other day. until it will probably all dissolve out into the country, as inevitable reaction.

FRANK LLOYD WRIGHT, *The Princeton Letters* (1930)

"Big" was the word. "Biggest" was preferred, and the "biggest in the world" was the braggart phrase on every tongue. Chicago had had the biggest conflagration "in the world." It was the biggest grain and lumber market "in the world." It slaughtered more hogs than any city "in the world." It was the greatest railroad center, the greatest this, the greatest that. The shouters could not very well be classed with the proverbial liars of Ecclesiastes, because what they said was true; and had they said, in the din, we are the crudest, rawest, most savagely ambitious dreamers and would-be doers in the world, that also might be true.

All this frothing at the mouth amused him at first, but soon he saw the primal power assuming self-expression amid nature's impelling urge. These men had vision. What they saw was real, they saw it as destiny.

LOUIS SULLIVAN, *The Autobiography of an Idea*

OPPOSITE: The Chicago Loop (second from left, Sullivan's Troescher Building, 1884. Demolished, 1978.)

PROTEST

The thoughtful mind must be impressed by a view of a great people unconscious and careless of its actual greatness, and grasping for the shadow they believe to be real. For this shadow they pursue with an idolatrous obsession; and the fair sunlight of their land and their institutions is held commonplace and valueless.

This sun, so much in obscuration nowadays, is the luminous spirit of Democracy.

Profoundly does the heart cry out in yearning that this light of life might shine forth in all its splendor upon upturned radiant faces, upon eyes that might see the clear blue vault of our national sky; and that this pig-like rooting and grunting and sniffing for the hidden Dollar might cease, if for but one clear-cut luminous moment at a time.

There is a far too wide-spread feeling that this deeply and seemingly surely-founded social fabric exists solely for personal profit and exploitation; and that, once his taxes are paid, or evaded, and his voting done or left undone, he, the individual, may move on in his narrow groove of self-interest without detriment to his fellows, to himself, or to his country.

<div align="right">

Louis Sullivan, *Kindergarten Chats*

</div>

OPPOSITE AND PAGES 78–83: The Schiller (later Garrick) Theater, Chicago, 1891–92. Demolished, 1961.

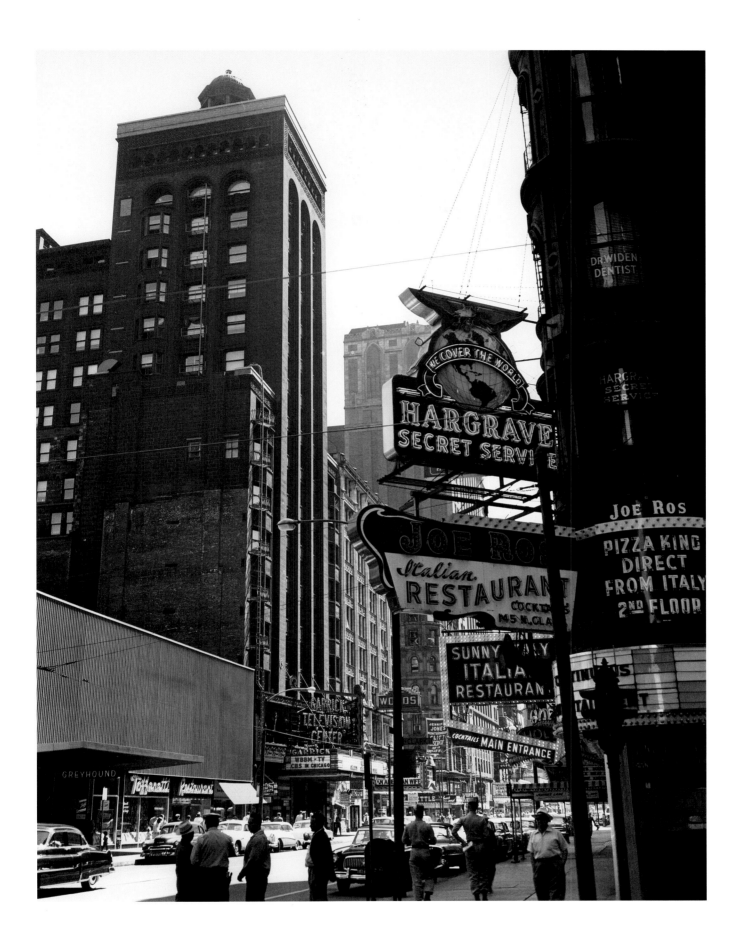

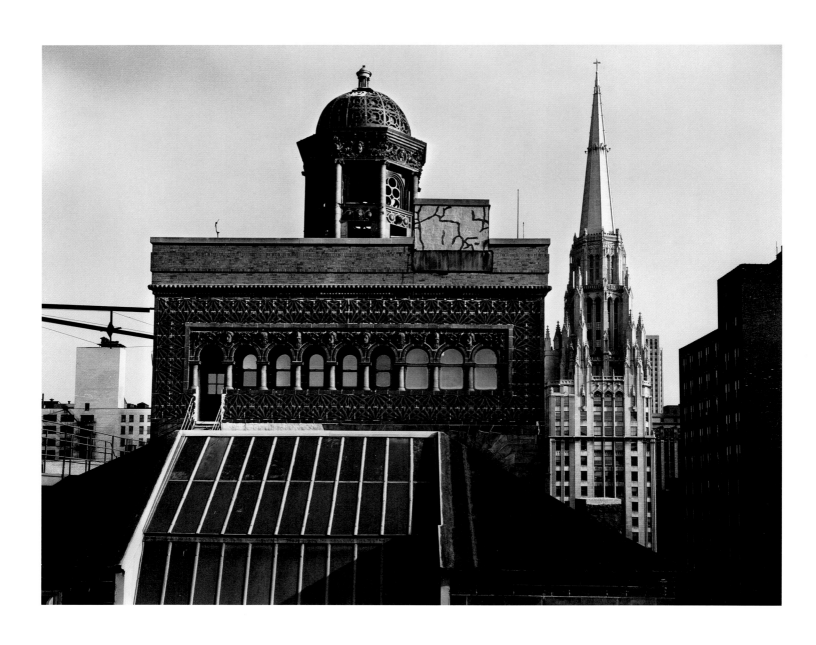

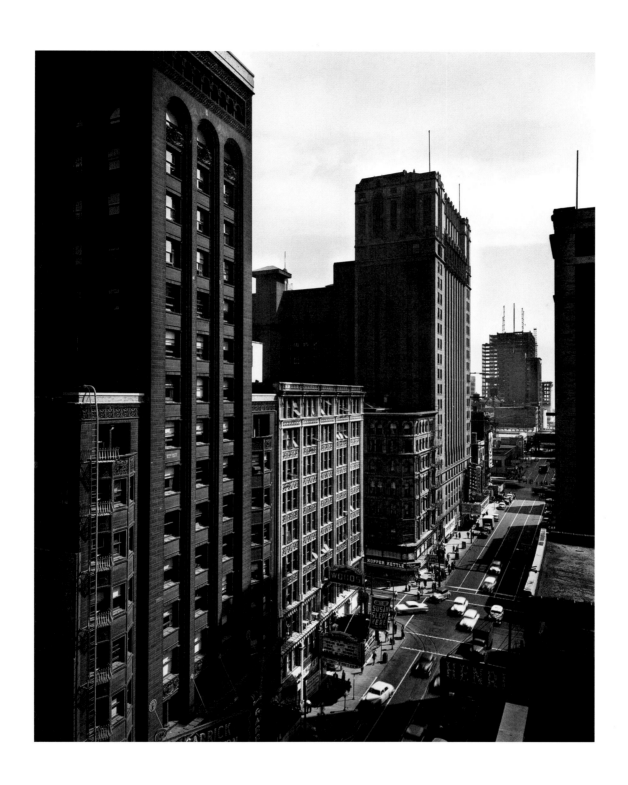

I have struck a city, — a *real city, — and they call it Chicago*. The other places do not count. Having seen it, I urgently desire never to see it again. It is inhabited by savages. Its water is the water of the Hugli, and its air is dirt. Also it says that it is the "boss" town of America.

When I went out into the streets, which are long and flat and without end, I looked down interminable vistas flanked with nine, ten, and fifteen storied houses, and crowded with men and women, and the show impressed me with a great horror. Except in London I had never seen so many white people together, and never such a collection of miserables. There was no colour in the street and no beauty — only a maze of wire-ropes overhead and dirty stone flagging underfoot.

I spent ten hours in that huge wilderness, wandering through scores of miles of these terrible streets, and jostling some few hundred thousand of these terrible people who talked money through their noses. It was like listening to a child babbling of its hoard of shells. It was like watching a fool play with buttons.

RUDYARD KIPLING, *From Sea to Sea: Letters of Travel*

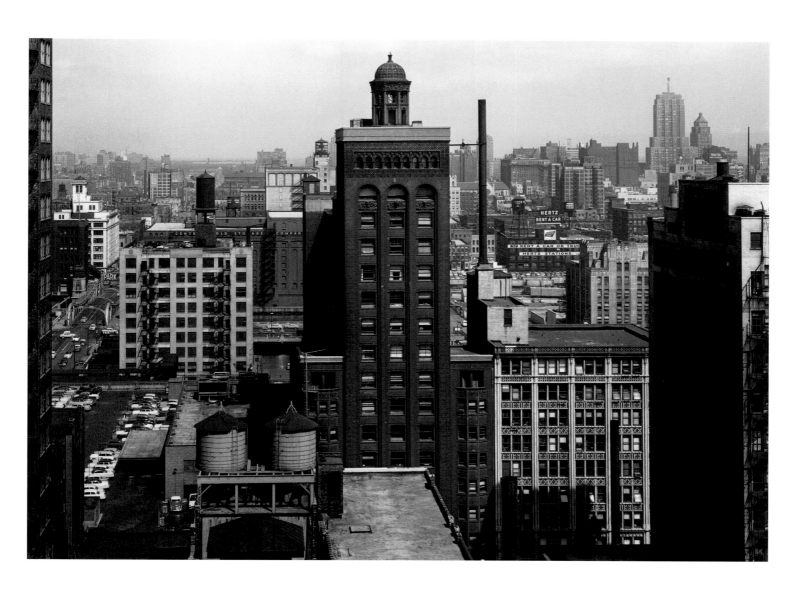

He had taken great pride in the performance of the Imperial Hotel, volunteered to write articles concerning it for the Architectural Record. "At last, Frank," he said, "something they can't take away from you." I wonder why he thought "they" couldn't take it away from me? "They" can take anything away from anybody.

FRANK LLOYD WRIGHT, *Genius and the Mobocracy*

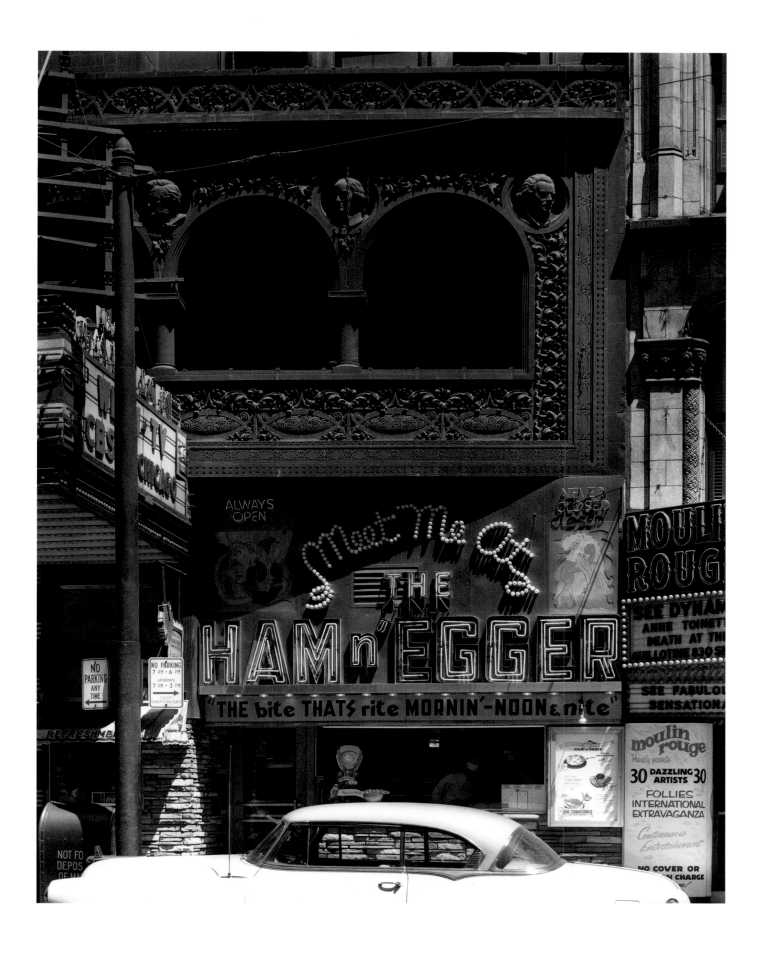

IV

NEW CAPTAINS AND A NEW CREED

When visiting the Sioux, I was led to the wigwam of the chief. It was like the others in external appearance, and even within the difference was trifling between it and those of the poorest of his braves. The contrast between the palace of the millionaire and the cottage of the laborer with us to-day measures the change which has come with civilization.

This change, however, is not to be deplored, but welcomed as highly beneficial. It is essential for the progress of the race that the houses of some should be the homes for all that is highest and best in the refinements of civilization. Much better this great irregularity than universal squalor. The "good old times" were not good old times. Neither master nor servant was as well situated then as to-day.

The price we pay for this salutary change is, no doubt, great. We assemble thousands of operatives in the factory, and in the mine, of whom the employer can know little or nothing, and to whom he is a little better than a myth. All intercourse between them is at an end. Rigid castes are formed, and, as usual, mutual ignorance breeds mutual distrust. Under the law of competition, the employer of thousands is forced into the strictest economies, among which the rates paid to labor figure prominently.

But, whether the law be benign or not, we must say of it. It is here; we cannot evade it; and while the law may be sometimes hard for the individual, it is best for the race, because it insures the survival of the fittest in every department.

ANDREW CARNEGIE, *The Gospel of Wealth*

LASALLE STREET: THE PIT

Within there, a great whirlpool spun and thundered, sucking in the life tides of the city, sucking them in as into the maw of some colossal sewer; then vomiting them forth again.

Terrible at the centre, it was, at the circumference, gentle, insidious and persuasive. But the circumference was not bounded by the city.

Because of an unexpected caprice in the swirling of the inner current, some far-distant channel suddenly dried, and the pinch of famine made itself felt among the vine dressers of Northern Italy, the coal miners of Western Prussia. Or another channel filled, and the starved moujik of the steppes, and the hunger-shrunken coolie of the Ganges' watershed fed suddenly fat and made thank offerings before ikon and idol.

There in the centre of the Nation, in the heart's heart of the affairs of men, roared and rumbled the Pit. It was as if the Wheat, as it rolled in a vast flood from West to East, here, like a Niagara, finding its flow impeded, burst suddenly into the chaotic spasm of a world-force, a primeval energy, blood-brother of the earthquake and the glacier, raging and wrathful that its power should be braved by some pinch of human spawn that dared raise barriers across its courses.

FRANK NORRIS, *The Pit*

OPPOSITE: The Chicago financial district (in the center, John Root's Rookery Building)

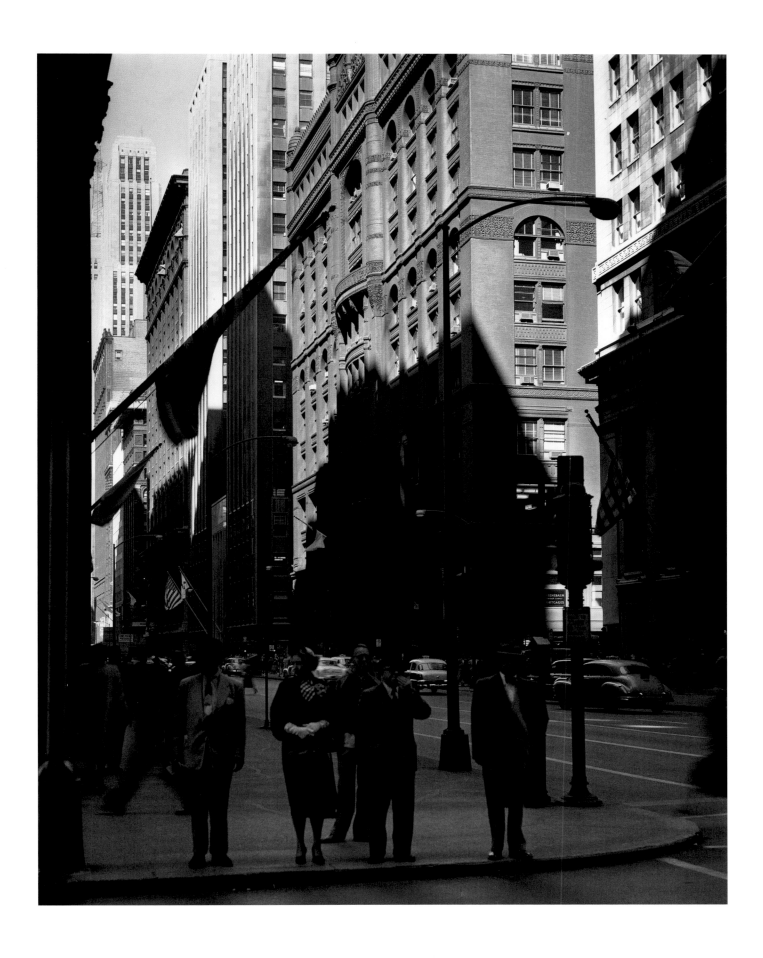

During this period there was well under way the formation of mergers, combinations and trusts in the industrial world. The only architect in Chicago to catch the significance of this movement was Daniel Burnham, for in its tendency toward bigness, organization, delegation, and intense commercialism, he sensed the reciprocal workings of his own mind.

In the turmoil of this immense movement railroads were scuttled and reorganized, speculation became rampant, credit was leaving terra firma, forests were slaughtered, farmers were steadily pushing westward, and into the Dakotas; immense mineral wealth had been unearthed. The ambitious traders sought to corner markets. The "corner" had become an ideal, a holy grail. Monopoly was in the air. Wall Street was a seething cauldron. The populace looked on, with open-mouthed amazement and approval, at the mighty men who wrought these wonders; called them Captains of Industry, Kings of this, Barons of that, Merchant Princes, Railroad Magnates, Wizards of Finance, or, as Burnham said one day to Louis: "Think of a man like Morgan, who can take a man like Cassatt in the palm of his hand and set him on the throne of the Pennsylvania!" And thus, in its way, the populace sang hymns to its heroes.

<div align="right">Louis Sullivan, The Autobiography of an Idea</div>

opposite and pages 90–99: The Chicago Stock Exchange (later 30 North LaSalle Building), 1893–94. Demolished, 1970–71.

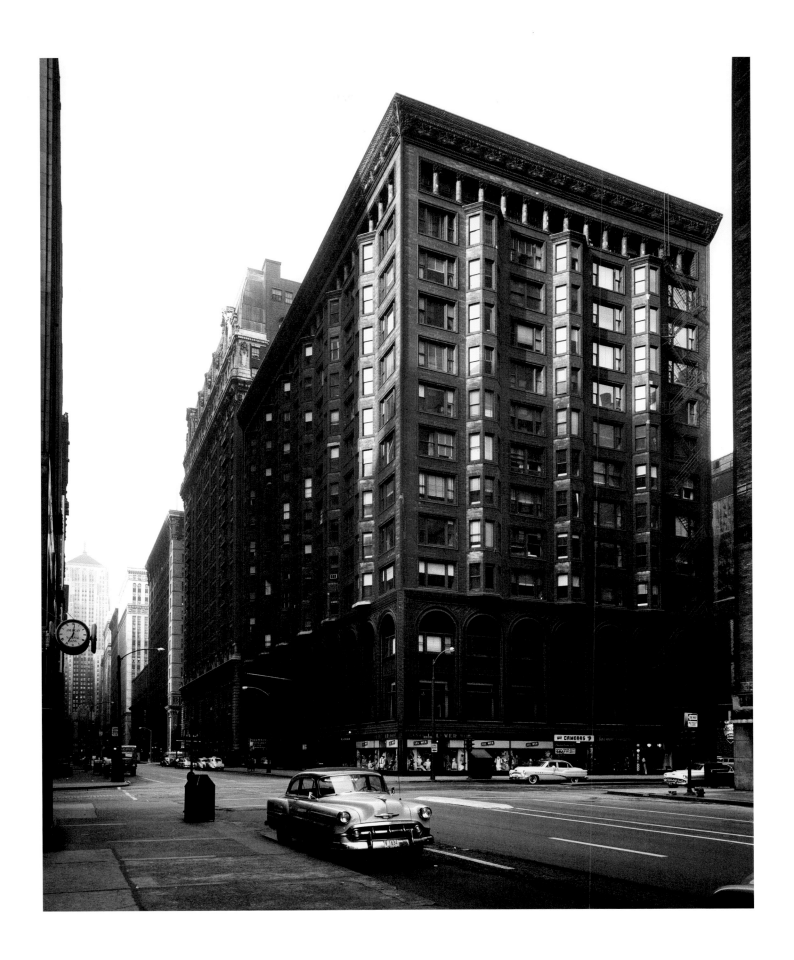

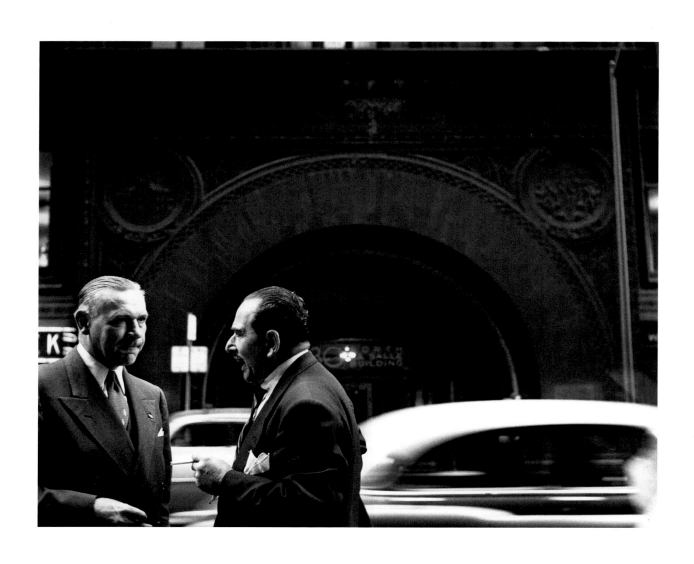

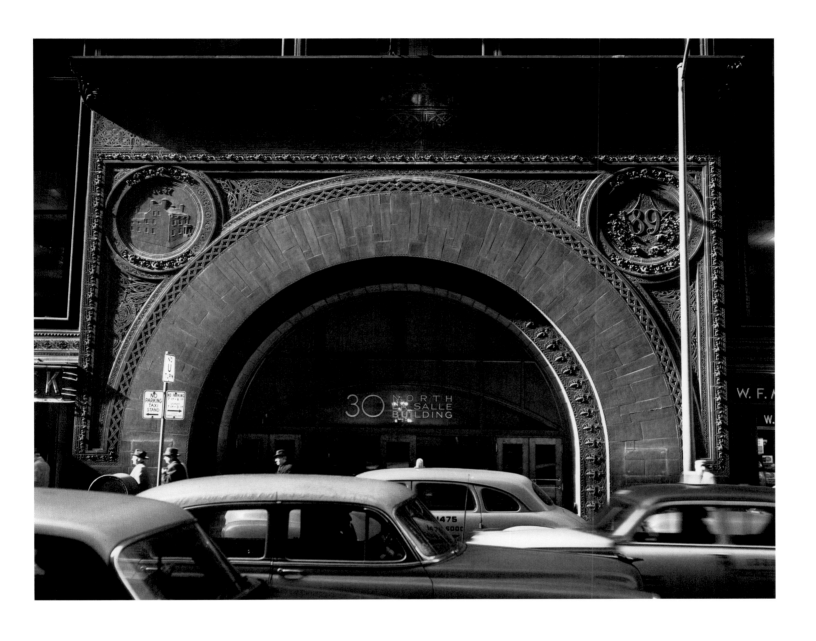

THE FAITH OF PHILIP ARMOUR

"I have no other interest in life but my business. I do not want any more money; as you say, I have more than I want. I do not love the money; what I do love is the getting of it, the making it. All these years of my life I have put into this work, and now it is my life and I cannot give it up. What other interest can you suggest to me? I do not read, I do not take any part in politics; what can I do? But in my counting house I am in my element; there I live, and the struggle is the very breath of life to me."

WILLIAM T. STEAD, *If Christ Came to Chicago*

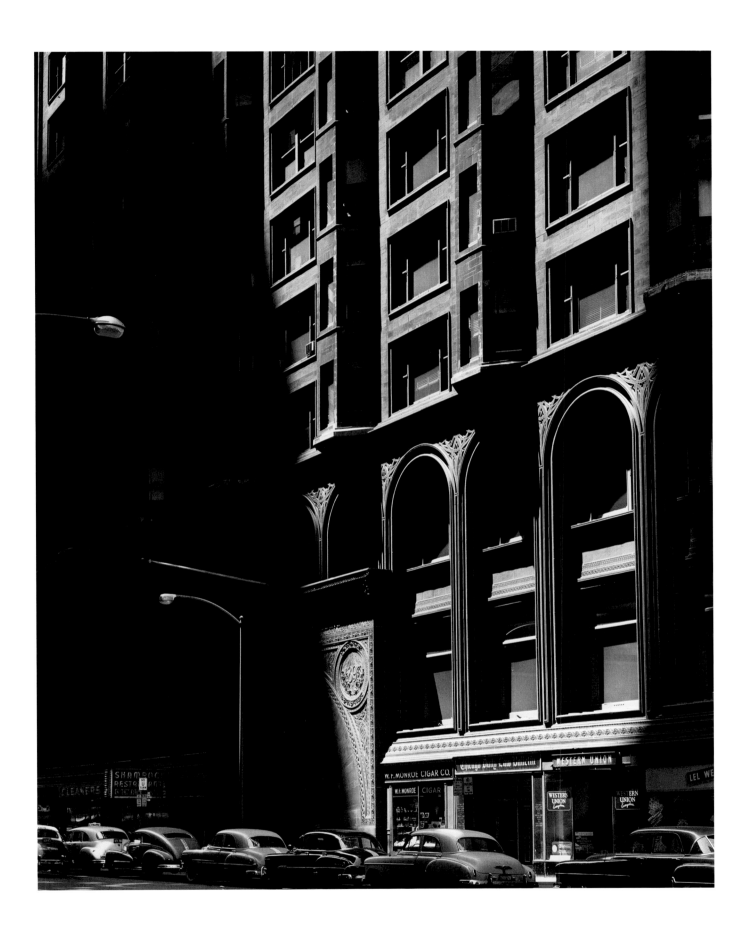

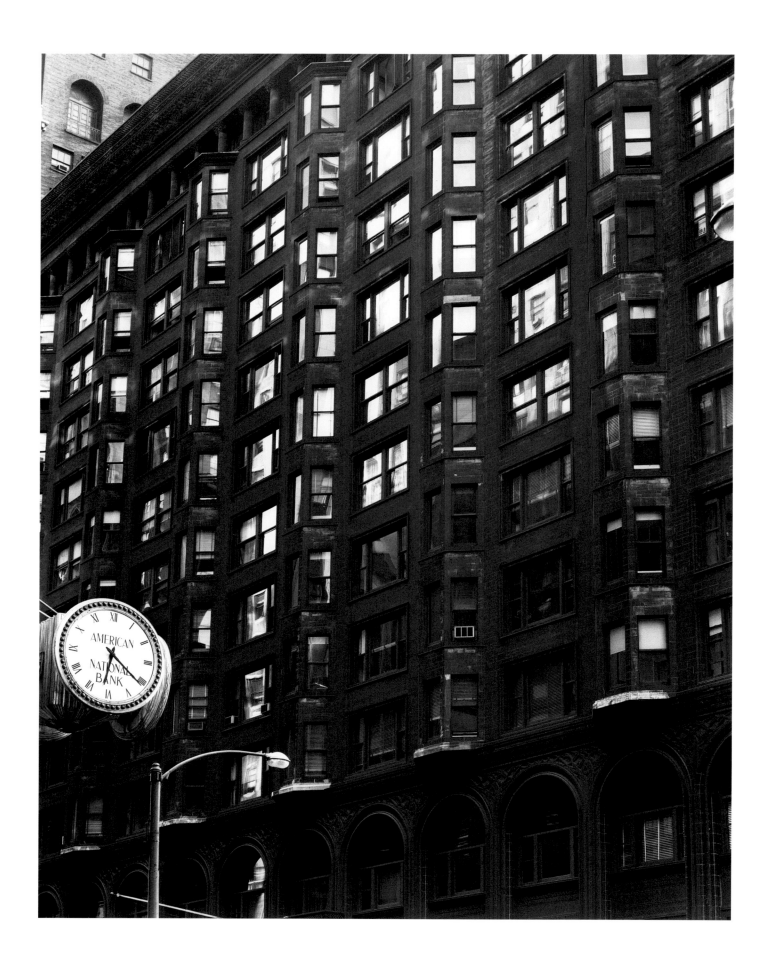

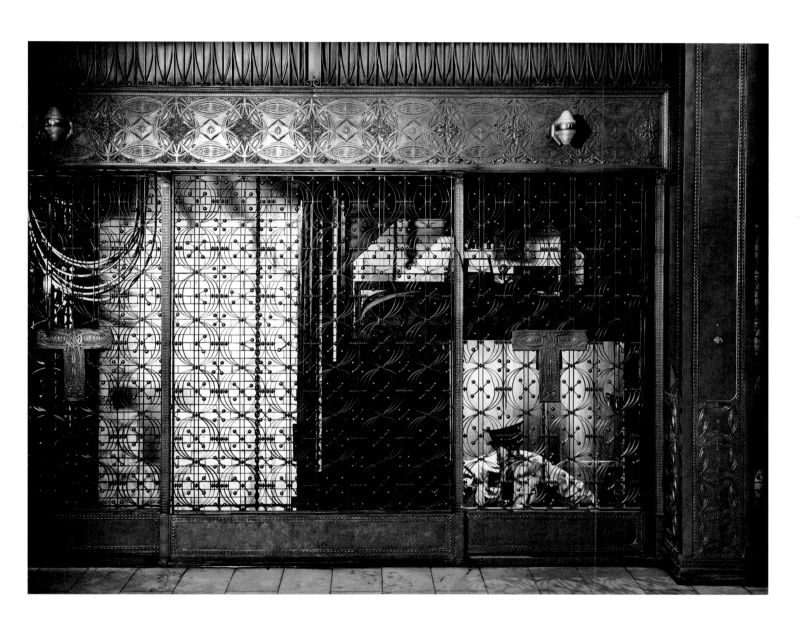

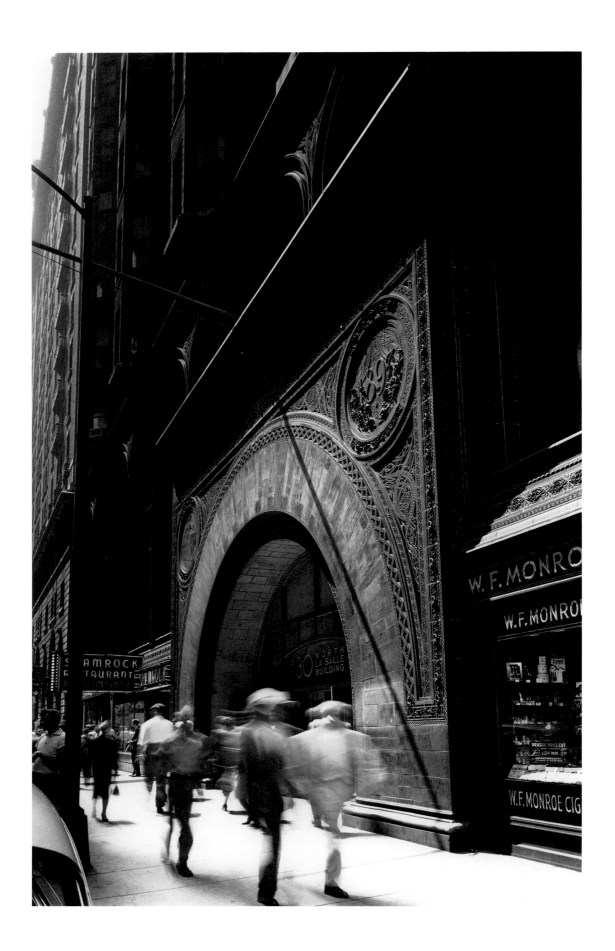

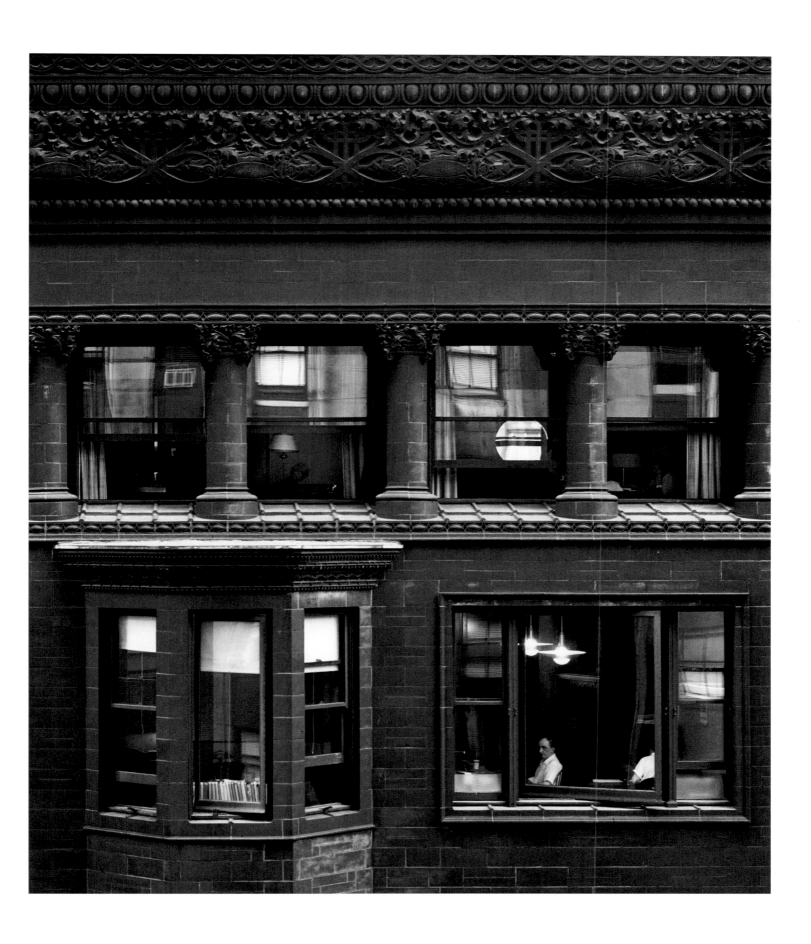

THE ACCOUNTING

If it happens that a given man be gifted, as is said, with stronger brain, more resolute will, a more fluid imagination, let him pause to reflect that these powers are not truly speaking his alone, that he did not make these original powers, but that they make him, and that they came to him out of the long birth-and-death struggle of the people of all times, and that he is answerable to all people — to the world — for their prolific democratic use.

It is precisely here that there must enter into the drama of democratic life the dominant roles of personal responsibility, personal accountability and self-government, if the powerfully equipped man is to be a blessing to his time and not a curse. Turn loose upon a people such a man lacking in such self-imposed restraint — and therefore feudal — and you are turning loose upon them a beast of prey: for he will use these powers for their exploitation, their suppression and his dominating aggrandizement. This is not, politely, called anarchy; but it is in fact a form of anarchy so insidious, so powerful, that the ranting of a few professional anarchists is as the sweet singing of birds in comparison.

Hence in a democracy there can be but one test of citizenship, namely: Are you using such gifts, such powers as you possess, for or against the march of spiritual freedom, the emancipation of man, and his powers, the unfolding of his knowledge and his understanding? Are you for or against the people?

LOUIS SULLIVAN, *Kindergarten Chats*

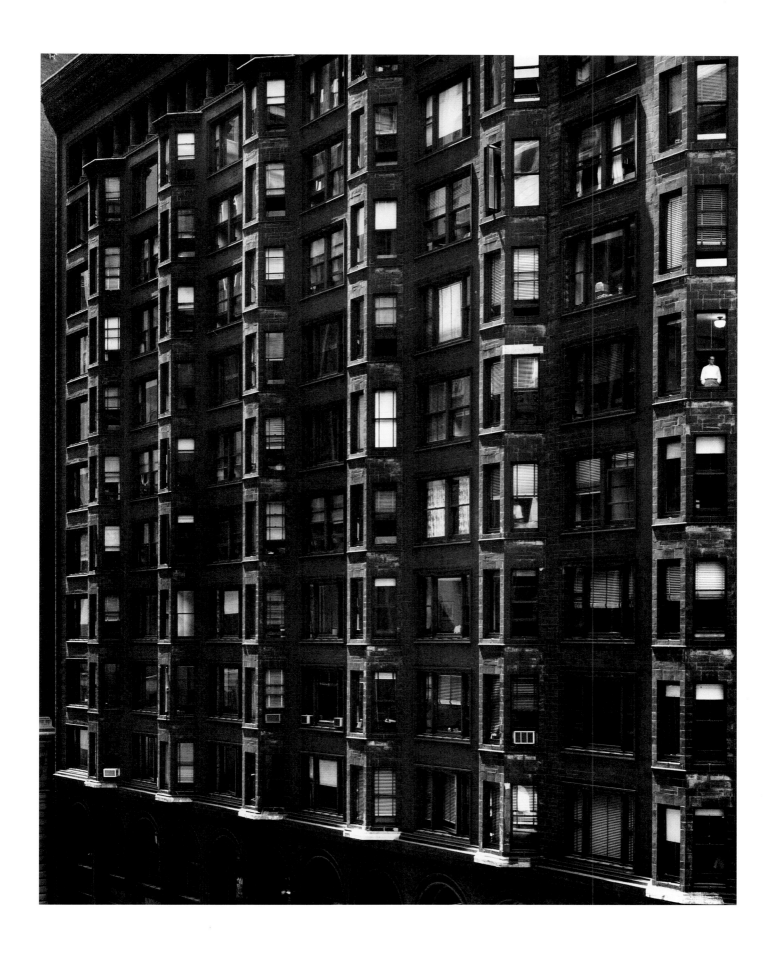

V

FUNCTION (IDEA, SPIRIT) AND FORM

THE MASTER: I am endeavoring to impress upon you the simple truth — immeasurable in power of expansion — of the subjective possibilities of objective things. In short, to clarify for you the origin and power of BEAUTY: to let you see that it is resident in function and form.

THE STUDENT: So is ugliness, isn't it?

THE MASTER: To be sure.

LOUIS SULLIVAN, *Kindergarten Chats*

FUNCTION AND FORM

THE MASTER: Now, it stands to reason that a thing looks like what it is, and, vice versa, it is what it looks like. I will stop here, to make exception of certain little straight brown canker-worms that I have picked from rose bushes. They looked like little brown, dead twigs at first. But speaking generally, outward appearances resemble inner purposes. For instances: the form, horse, resembles and is the logical output of the function, horse; the form, spider, resembles and is tangible evidence of the function, spider.

Like sees and begets its like. That which exists in spirit ever seeks and finds its physical counterpart in form, its visible image; a monstrous thought, a monstrous form; a thought in decadence, a form in decadence; a living thought, a living form.

THE STUDENT: Well, I suppose of course there is some application of this to architecture? I suppose if we call a building a form —

THE MASTER: You strain my nerves — but go on.

THE STUDENT: I suppose if we call a building a form, then there should be a function, a purpose, a reason for each building, a definite explainable relation between the form, the development of each building, and the causes that bring it into that particular shape; and that the building, to be good architecture, must, first of all, clearly correspond with its function, must be in its image, as you would say.

THE MASTER: Yes, yes. Very good as far as you go. But I wish to warn you that a man might follow the program you have laid down, and yet have, if that were his makeup, a very dry, a very pedantic, a very prosaic result. He might produce a completely logical result, so-called, and yet an utterly repellent one — a cold, a vacuous negation of living architecture — a veritable pessimism.

THE STUDENT: How so?

THE MASTER: Simply because logic, scholarship, or taste, or all of them combined, cannot make organic architecture. They may make logical, scholarly or "tasty" buildings, and that is all. And such structures are either dry, chilling or futile.

LOUIS SULLIVAN, *Kindergarten Chats*

OPPOSITE AND PAGES 105–19: The Guaranty (now Prudential) Building, Buffalo, New York, 1894–95

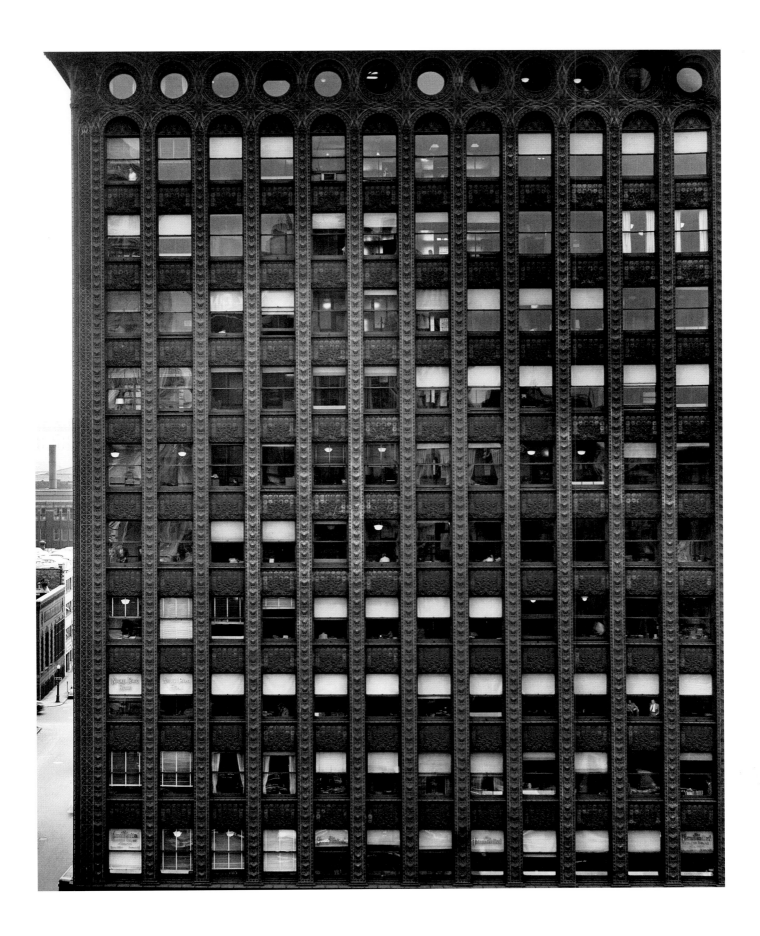

TOWARD AN ORGANIC ARCHITECTURE

It must be manifest that an ornamental design will be more beautiful if it seems a part of the surface or substance that receives it than if it looks "stuck on," so to speak. A little observation will lead one to see that in the former case there exists a peculiar sympathy between the ornament and the structure, which is absent in the latter. Both structure and ornament obviously benefit by this sympathy; each enhancing the value of the other. And this, I take it, is the preparatory basis of what may be called an organic system of ornamentation.

The ornament, as a matter of fact, is applied in the sense of being cut in or cut on, or otherwise done: yet it should appear, when completed, as though by the outworking of some beneficent agency it had come forth from the very substance of the material and was there by the same right that a flower appears amid the leaves of its parent plant.

Here by this method we make a species of contact, and the spirit that animates the mass is free to flow into the ornament — *They are no longer two things but one thing.*

LOUIS SULLIVAN, *Ornament in Architecture*

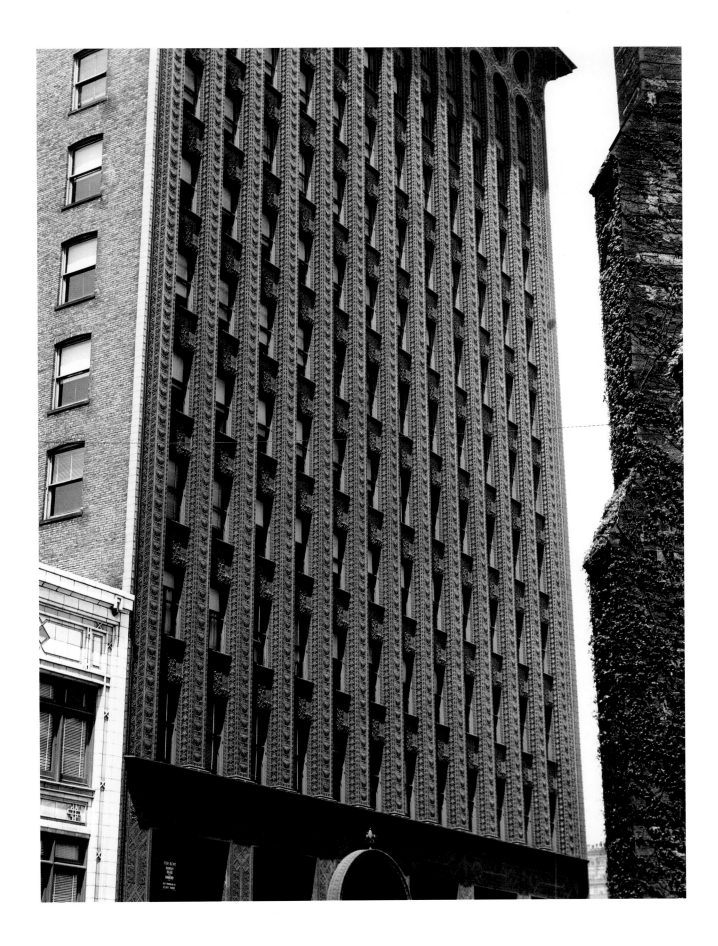

NOW THE REAL MAN BEGINS TO SHAPE WITHIN OUR VISION.

Consider his primary powers: He, the *worker*, the *inquirer*, the *chooser*. Add to these the wealth of his emotions — also powers. Think how manifold they are, how colorful; how with them he may dramatize his works, how he may beautify his choice. Think of his power to receive through his senses, to receive through his mystic power of sympathy which brings understanding to illumine Knowledge. Think of what eyesight means as a power, the sense of touch, the power to hear, to listen; the power of contemplation. Deep down within him lies that power we call Imagination, the power instantly or slowly to picture forth, the power to act in advance of action; the power that knows no limitations; the inscrutable dynamic power that energizes all other powers. Think of man as Imagination! Then think of him as Will! Think anew of his power to act.

Now think of the Freedom such power brings!

LOUIS SULLIVAN, *The Autobiography of an Idea*

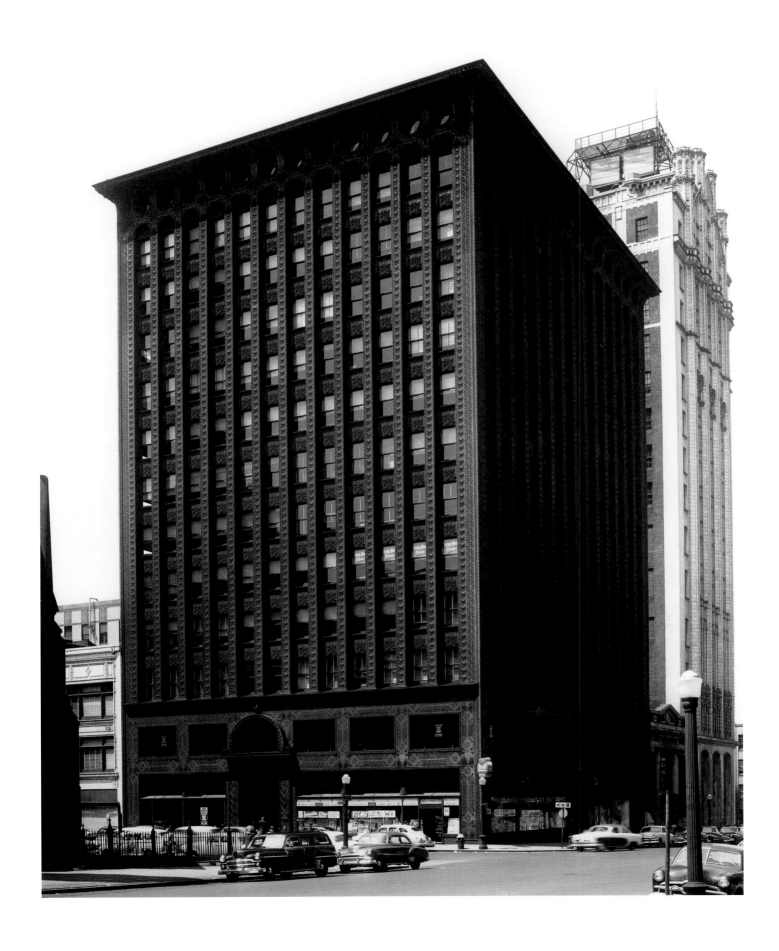

REVULSION . . .

THE STUDENT: I have had my little emotional, and intellectual, and moral and spiritual, and democratic, and feudal jag, my fidus Achates — my friend, philosopher, hocus-pocus and guide. I, no adept in philosophy, have been philosophized to death, burdened, darkened, nauseated and made rebellious by your pseudo-mysticism. For what use there is in it I can't perceive.

Away, all these fantasies, these supersensibilities! Freedom is a curse, not a blessing! Democracy is a humbug and a wild, disordered dream. It is the refuge of the common, the average, the vulgar. Democracy eats with its knife. Do you mean to tell me that a man can be a real man in a Democracy! A Dollar-man, yes! A cheap Dollar-man, cheap among the cheap. Look at the faces: all sordid, all pig-eyed, all self-centered in their democratic savagery; all cave-dwellers, men of a modern stone-age, with dirt under their brain-claws. You talk of men!

Democracy is a rough and tumble affair, and I know it. The people don't know anything and don't want to know anything, and do you think I'm going to be fool enough to try to tell them anything they don't want to know? Not much! You know as well as I do that the Nazarene said, "Cast not pearls before swine lest they turn and rend you." Try them once. Try a few pearls — and look out for the teeth! So if my generation is unreal, I am going to be unreal also; for all the leading men in a democracy understand and cater to the stupidity of the masses.

Democracy means, merely, the liberation of numbers, the wandering and huddling of helpless units. It means disorder, filth, brutal unity, coarse appetites — a stifling crowd! Give me an autocrat! Give me the strong hand, the iron will, the keen intelligence, and that higher sense of humanity which can care for the herd and protect the herd against the hoof disease of its own cowardly crowding, and against the insistence of its own proletariat. The very disease of which you are talking and have been talking is *democracy itself*; for democracy is, in itself, a disease.

THE MASTER: You are a fool, an ass.

THE STUDENT: I am not a fool. I tell you —

THE MASTER: Tell me nothing! You have emptied your bile duct, now go and sleep!

THE STUDENT: Am I not right in the main?

THE MASTER: Yes, after a fashion.

THE STUDENT: Then everything is as I say?

THE MASTER: I have told you: you are an ass.

LOUIS SULLIVAN, *Kindergarten Chats*

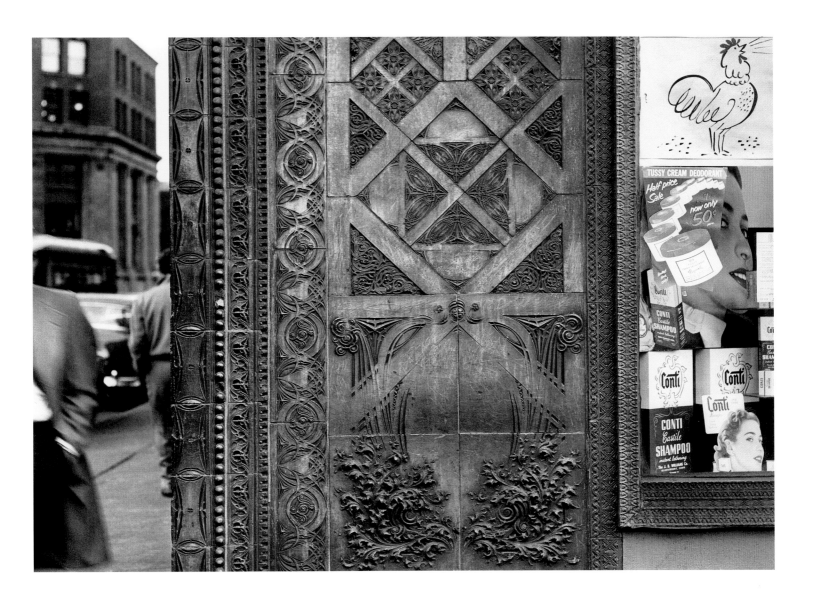

... AND RETURN

THE STUDENT: Here comes your bad penny again! I have passed through Q for querulity, and am safely landed, now, on R for remorse. I want you to pull me out of my light and into your light concerning this matter of democracy.

THE MASTER: Well then, come into my light: for small as it is, it is large enough for two: though, large as it is, it seems too small for one. For, after all, what do we know of the broad spectacle of democracy! We search, and seek, and probe, and test, and analyze, and surmise, and hope and fear, and are filled with useless longings, useless regrets; and after all these trials, our own people, the people among whom we live and move and have our being seem as strange to us as are the Antipodeans — the denizens of far-off forests and isles. But let us garner up our hearts, and come back, little by little, upon our own land. For that which is sown in affection surely will eventuate in love; and just so surely will we come nearer and nearer to our people.

Thus democracy will begin to unfold itself to us as the expression of the individual. In so far as the individual errs, democracy errs, and in so far as the individual grows and develops in the right, democracy gains thereby and grows and flourishes. *Democracy is primarily of the individual!* It is not a mere political fabric, a form of government; that is but one phase of it — an incidental phase. Democracy is a *moral* principle, a *spiritual* law, a perennial subjective reality in the realm of man's spirit. It is an aspiring power whose roots run deep into those primal forces that have caused man to arise from the elements of earth and, slowly through the ages, to assume a rectitude and poise that are of man alone. Democracy is a vast, slowly-urging impulse which little by little and more and more broadly is ever exalting man in spirit and imparting to him a definition of his true image — his true power. Just as man was ages upon ages in learning to stand on his feet in a physical sense, so is there an impulse ever at work, ever tending to imbue him with the power to stand upon his feet, morally, and this force we call democracy.

By this light, surely, ours is the land of destiny! Here nature had prepared, through the ages, a slumbering continent, a virgin wilderness, to be the home of free men — that the silently working calm and the power of the wilderness might permeate them, and lift them up to be a great people animated by a great purpose, a great force, a great beauty — the beauty and the power and the glory of democracy — the divine altitude of man's humanity.

Why then pick at little flaws, why point to petty truths, if the doing leads but to obscuration of a living principle? Rather shall we seek the broad truth, the sure truth, the basic truth of our destiny, and gauge our thoughts, our conduct and our art thereunto.

LOUIS SULLIVAN, *Kindergarten Chats*

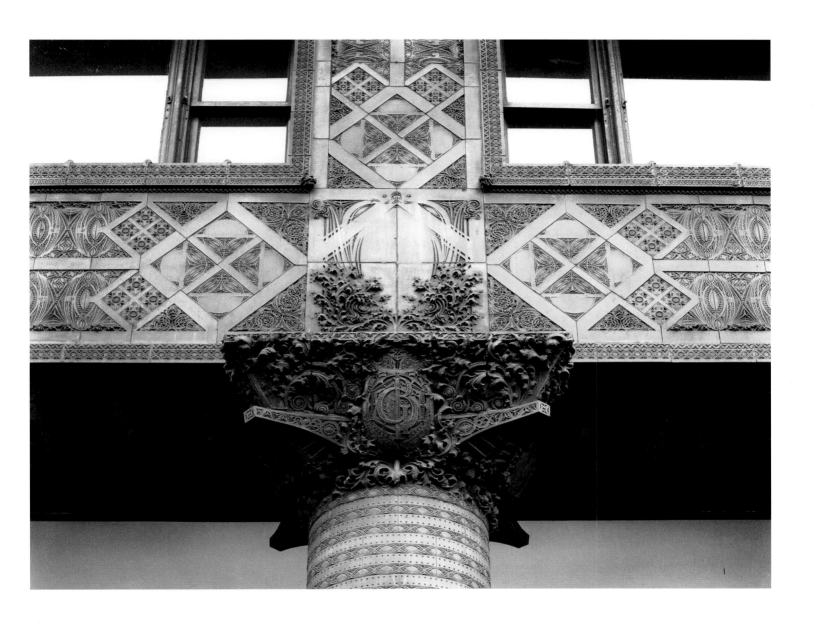

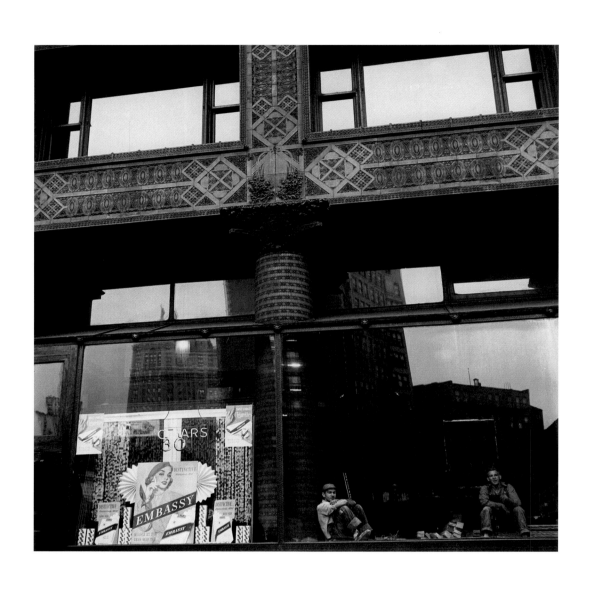

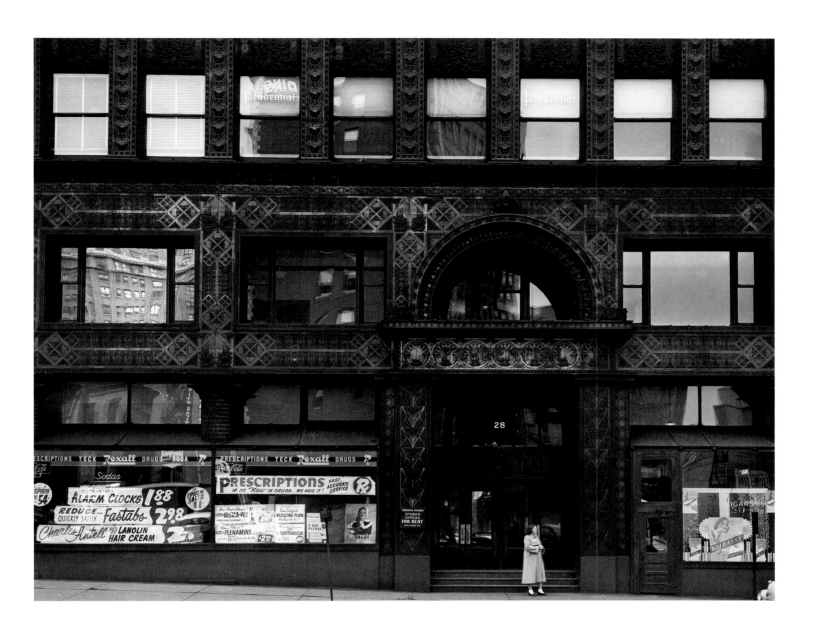

Truly we are face to face with great things.

The mind of youth should be squarely turned to these phenomena.

He should be shown, as a panorama, as a great drama, the broad sweep and flow of the vast life in which he is a unit, an actor.

He should be shown what the reality of history shows, namely, that optimism is an abiding emotion in the heart of the race.

He must be imbued with that pride, that sure quality of honor, which are the ethical flower of self-government and the sense of moral responsibility.

He should be taught that a mind empty of ideals is indeed an empty mind, and that the highest of ideals is the ideal of democracy.

The beauty of nature should most lovingly be shown to him.

He should be taught that he and the race are inseparably a part of nature.

He should be taught that the full span of one's life is but a little time in which to accomplish a worthy purpose; and yet he should be shown what men have done.

I advocate a vigorous, thorough, exact mental training, which shall fit the mind to develop individual judgment, capacity and independence.

But at the same time I believe that sympathy is a safer power by far than intellect. Therefore would I train the individual sympathies as carefully in all their delicate warmth and tenuity as I would develop the mind in alertness, poise and security.

Nor am I of those who despise dreamers. For the world would be at the level of zero were it not for its dreamers — gone and of today.

So would I nurse the dreamer of dreams, for in him nature broods while the race slumbers.

LOUIS SULLIVAN, *Education*

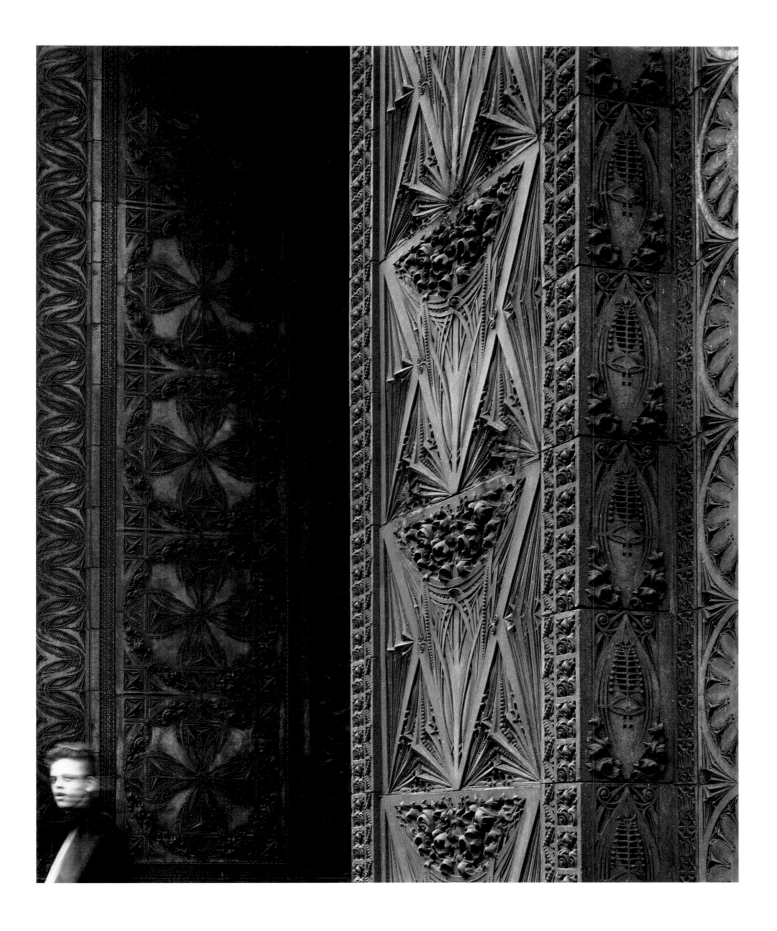

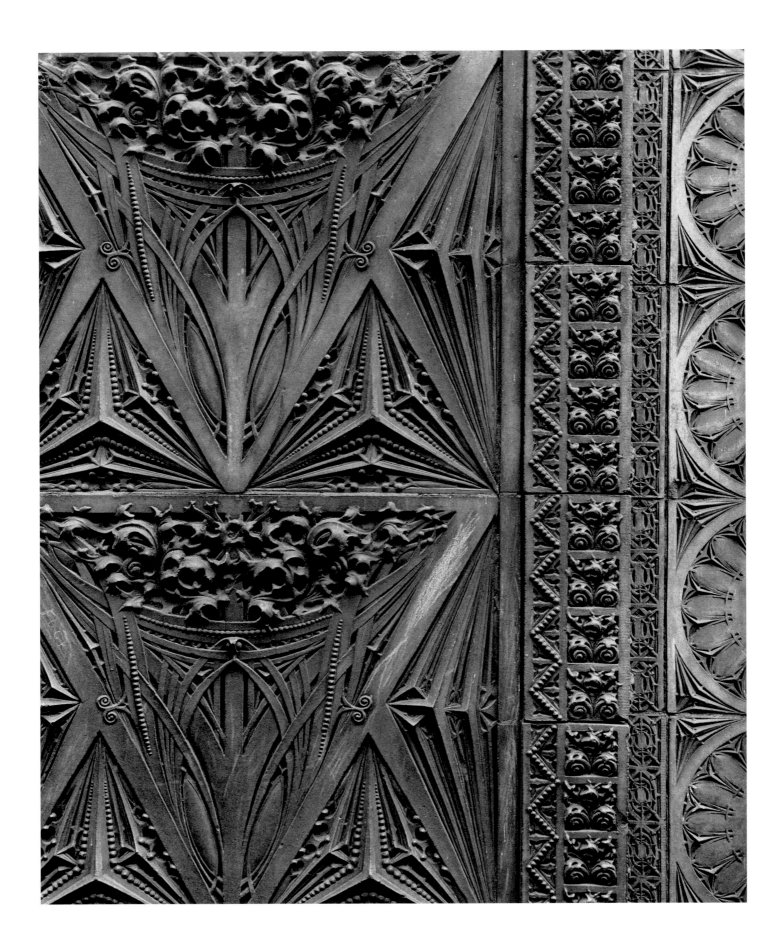

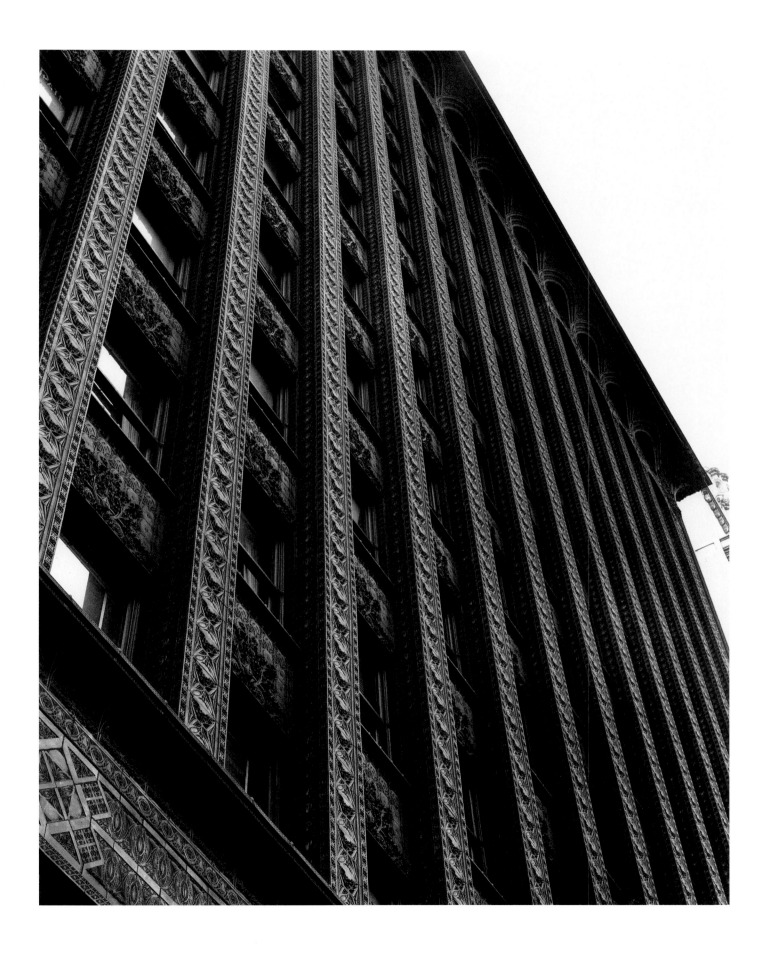

Of one hundred so-called thoughts that the average man thinks (and thus he has ever thought), ninety-nine are illusions, the remaining one a caprice.

From time to time in the past, these illusions have changed their focus and become realities, and the one caprice has become an overwhelming desire.

These changes were epoch-making.

And the times were called golden.

In such times came the white-winged angel of sanity.

And the great styles arose in greeting.

Then soon the clear eye dimmed.

The sense of reality was lost.

Then followed architectures, to all intents and purposes quite like American architecture of today:

Wherein the blind sought much discourse of color.

The deaf to discuss harmonics.

The dry heart twaddled about the divinity of man.

The mentally crippled wrought fierce combats in the arena of logic.

<div align="right">LOUIS SULLIVAN, The Young Man in Architecture</div>

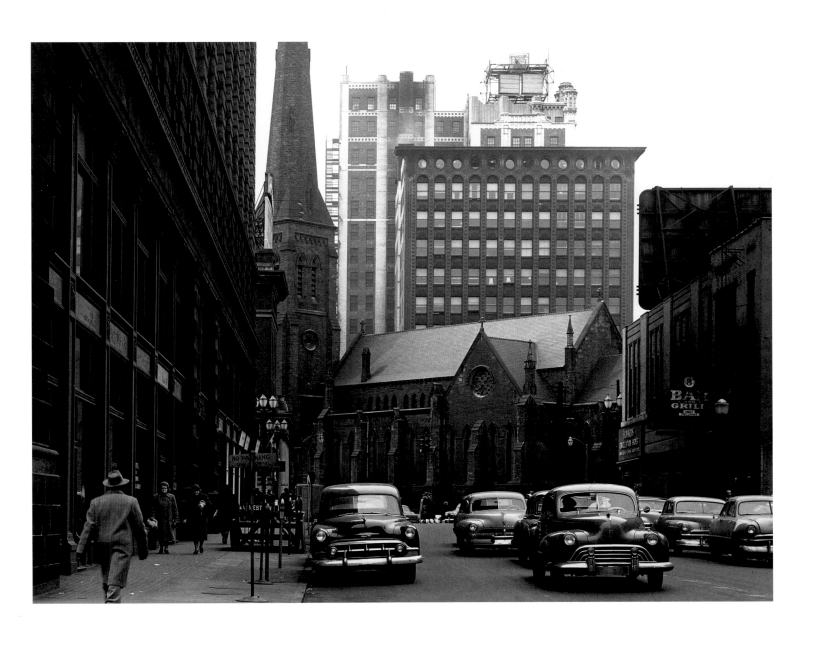

VI

THE VICTORY OF THE HIGHER CULTURE

It was deemed fitting by all the people that the four hundredth anniversary of the discovery of America by one Christopher Columbus, should be celebrated by a great World Exposition, which should spaciously reveal to the last word the cultural status of the peoples of the Earth, and that the setting for such display should be one of splendor, worthy of its subject.

<div align="right">

LOUIS SULLIVAN, *The Autobiography of an Idea*

</div>

The Exposition itself defied philosophy. One might find fault till the last gate closed, one could still explain nothing that needed explanation. As a scenic display, Paris never approached it, but the inconceivable scenic display consisted in its being there at all — more surprising, as it was, than anything else on the continent, Niagara Falls, the Yellowstone Geysers, and the whole railway system thrown in, since these were all natural products in their place; while, since Noah's ark, no such Babel of loose and ill-joined, such vague and ill-defined and unrelated thoughts and half-thoughts and experimental outcries as the Exposition, had ever ruffled the surface of the Lakes.

The first astonishment became greater every day. That the Exposition should be a natural growth and product of the Northwest offered a step in evolution to startle Darwin, but that it should be anything else seemed an idea more startling still; and even granting that it were not — admitting it to be a sort of industrial, speculative growth and product of the Beaux Arts artistically induced to pass the summer on the shore of Lake Michigan — could it be made to seem at home there? Was the American made to seem at home in it? Honestly, he had the air of enjoying it as though it were all his own; he was proud of it. If he had not done it himself, he had known how to get it done to suit him. Perhaps he could not do it again; the next time he would want to do it himself and would show his own faults; but for the moment he seemed to have leaped directly from Corinth and Syracuse and Venice to impose classical standards on plastic Chicago.

<div align="right">

HENRY ADAMS, *The Education of Henry Adams*

</div>

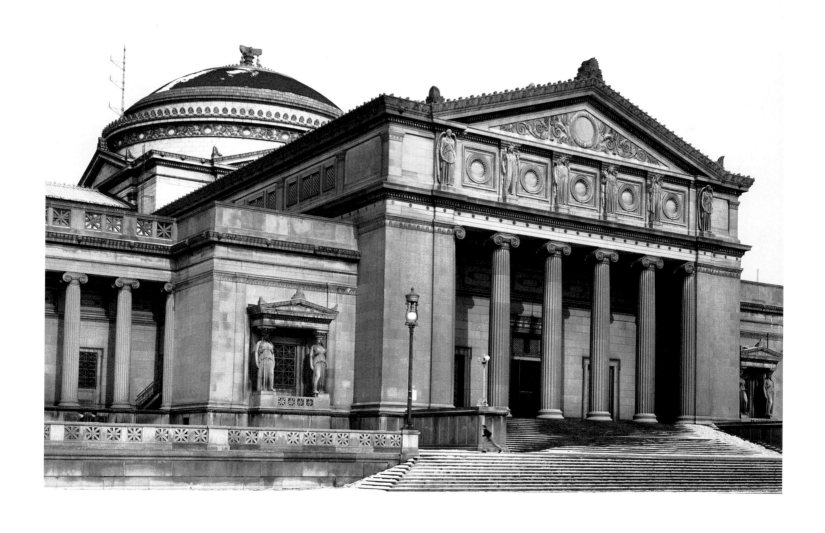

1893: THE WORLD'S FAIR

These crowds were astonished. They beheld what was for them an amazing revelation of the architectural art. To them it was a veritable Apocalypse, a message inspired from on high. Upon it their imagination shaped new ideals. They went away, spreading again over the land, returning to their homes, each of them permeated by the most subtle and slow-acting of poisons. A vast multitude, exposed, unprepared, they had not had time nor occasion to become immune to forms of sophistication not their own, to a higher and more dexterously insidious plausibility. Thus they departed joyously, carriers of contagion, unaware that what they beheld and believed to be truth was to prove, in historic fact, an appalling calamity. For what they saw was not at all what they believed they saw, but an imposition of the spurious upon their eyesight, a naked exhibitionism of charlatanry.

LOUIS SULLIVAN, *The Autobiography of an Idea*

Stunned by the majesty of the vision, my mother sat in her chair, visioning it all yet comprehending little. Her life had been spent among homely small things, and these gorgeous scenes dazzled her, overwhelmed her, letting in upon her in one mighty flood a thousand stupefying suggestions of the art and history and poetry of the world.

At the end of the third day father said, "Well, I've had enough." In truth they were both surfeited with the alien, sick of the picturesque.

However I observed that the farther they got from the Fair the keener their enjoyment of it became! Scenes which had worried as well as amazed them were now recalled with growing enthusiasm, as our train, filled with other returning sightseers of like condition, rushed steadily northward into the green abundance of the land.

HAMLIN GARLAND, *Son of the Middle Border*

OPPOSITE AND PAGE 125: The Palace of Fine Arts, Columbian Exposition, 1893 (now Chicago Museum of Science and Industry)

MR. WARD MCALLISTER: *Leaders in the Windy City are undoubtedly great in their way, but perhaps in some cases unfamiliar with the niceties of life and difficult points of etiquette.*

To the artists of America the Fair meant the public recognition of their work in conjunction with one another. Standards of achievement and taste had been created. Eclecticism and freakishness, falsely called originality, had been discredited; and the treasure-houses of the past opened doors long closed to Americans, because never attempted. Suddenly we became heirs to untold riches in art. And then it was discovered that much of what seemed new and unaccustomed was but a return to early days, when the traditions of Sir Christopher Wren had been followed in the colonial architecture of America by builders who by no means changed their natures when they changed their skies. And more careful study revealed the encouraging fact that in planning the earliest public buildings of the new republic, Washington and Jefferson had insisted on classic precedents. So that in the last analysis the new movement was but a return to our better selves.

CHARLES MOORE, *Daniel Burnham: Architect, Planner of Cities*

The virus of the World's Fair began to show unmistakable signs of the nature of the contagion. There came a violent outbreak of the Classic and the Renaissance in the East, which slowly spread westward, contaminating all that it touched. The selling campaign of the bogus antique was remarkably well managed through skillful publicity and propaganda, by those who were first to see its commercial possibilities. By the time the market had been saturated, all sense of reality was gone. In its place had come deep-seated illusions, hallucinations, absence of pupillary reaction to light, absence of knee-reaction — symptoms all of progressive cerebral meningitis: The blanketing of the brain.

LOUIS SULLIVAN, *The Autobiography of an Idea*

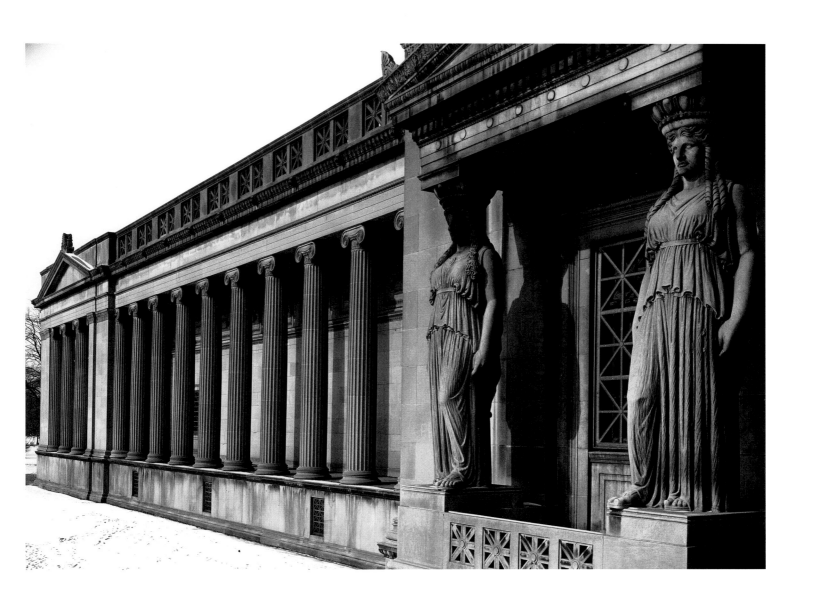

Thus architecture died in the land of the free and the home of the brave, — in a land declaring its fervid democracy, its inventiveness, its resourcefulness, its unique daring. Thus did the virus of a culture, snobbish and alien to the land, perform its work of disintegration; and thus ever works the pallid academic mind, denying the real, exalting the fictitious; that never lifts a hand in aid because it cannot; that turns its back upon man because that is its tradition; a culture lost in a ghostly *mésalliance* with abstractions, when what the world needs is courage, common sense and human sympathy, and a moral standard that is plain, valid and livable.

The damage wrought by the World's Fair will last for a half century from its date, if not longer. It has penetrated deep into the constitution of the American mind, affecting there lesions significant of dementia.

Louis Sullivan, *The Autobiography of an Idea*

OPPOSITE: Monuments of the period

126

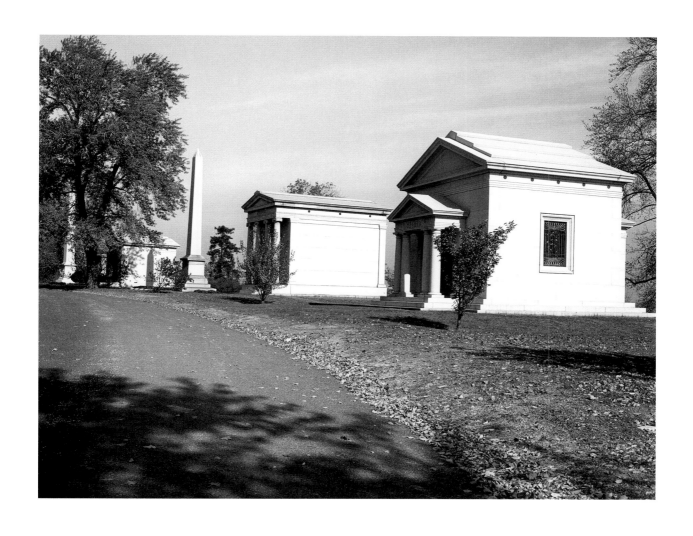

Lord of this vast o'erhanging sky, Lord of the wintry heart,
Lord of every sombre tree and pallid snowflake!
Why has thou let a winter fall upon my soul?
Why are the seeds of my spirit dormant?
Why are fair flowers of my fancy moribund?

Spirit Sublime! Why hast thou let a winter fall upon the hearts of my countrymen?

Have I not lived for my art? — an art grown up in praise of thee.

Must I then die for it?

And, dying, leave nought behind else a few precarious, scattered seeds, overlaid with snow — when my heart was so filled with fertility, in thine honor.

Alas! There is no answer.

So, must I seek my way alone — if way there be.

So, must my soul abide its wintertime.

So, must the tiny, hidden seed of hope await the day.

LOUIS SULLIVAN, *Kindergarten Chats*

OPPOSITE AND PAGES 130–33: The Getty Tomb, Graceland Cemetery, Chicago, 1890

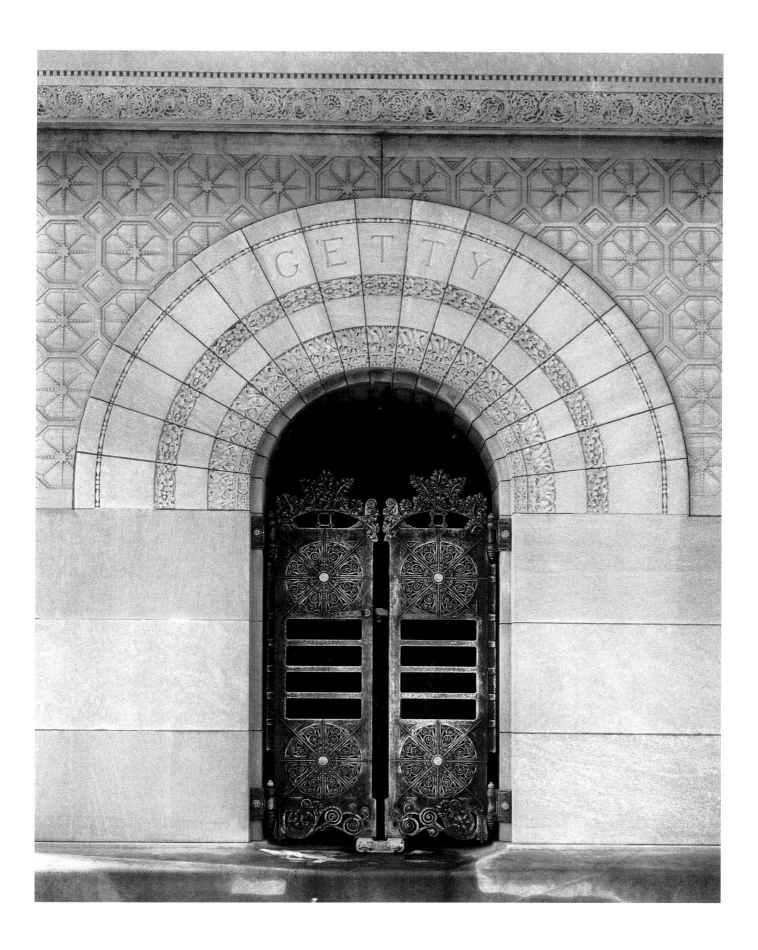

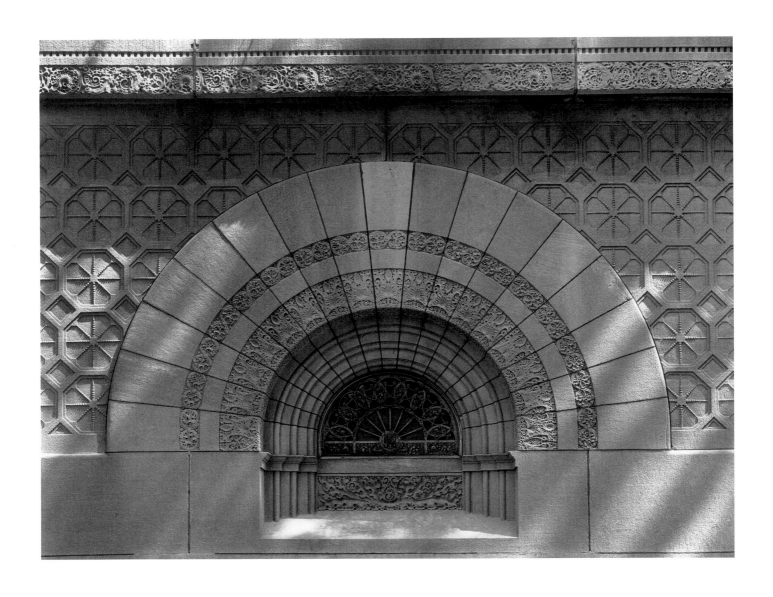

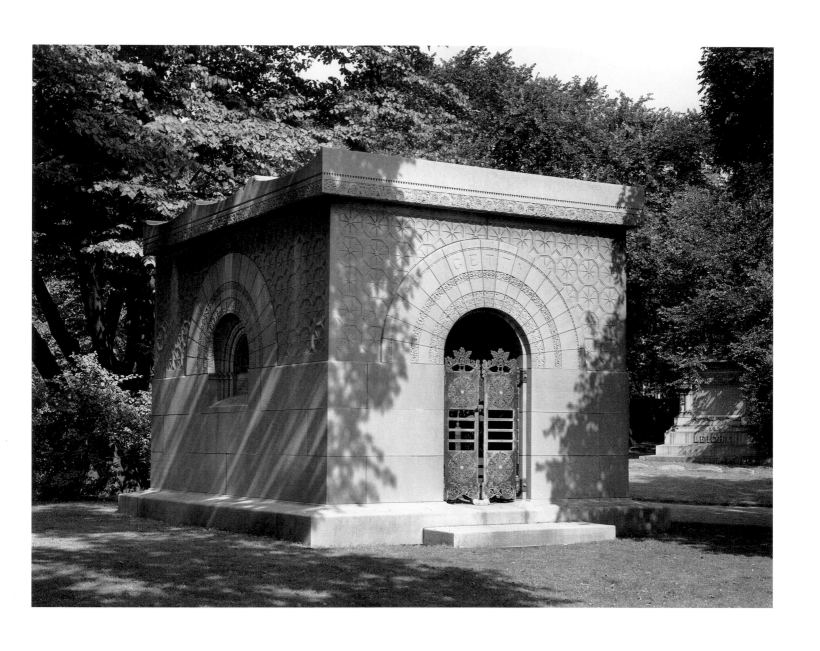

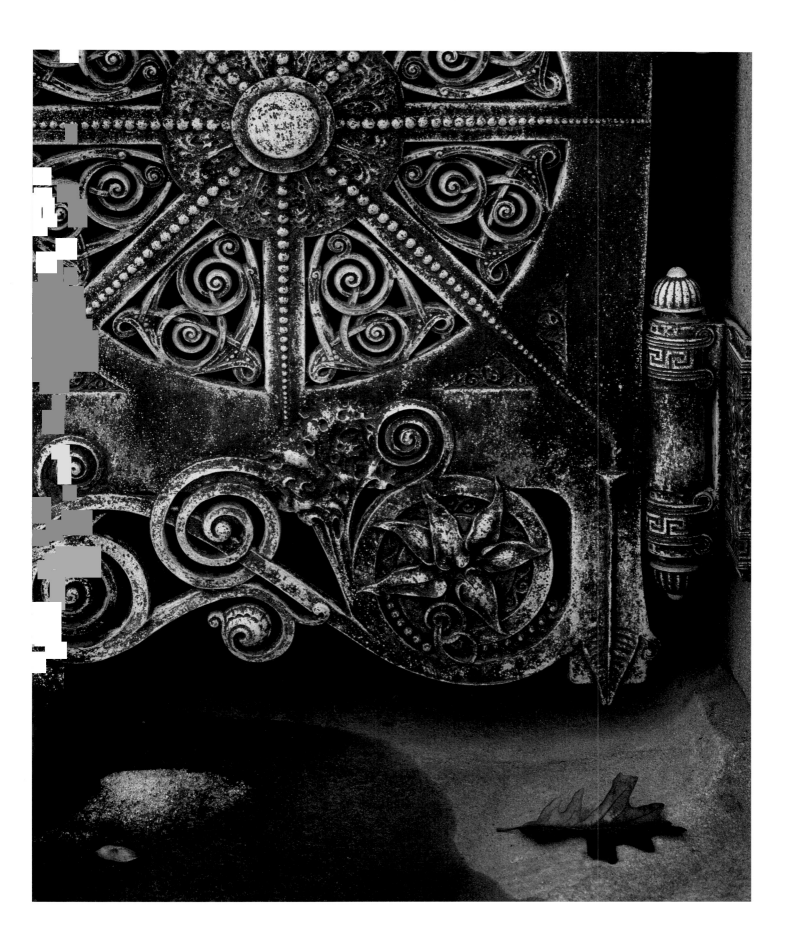

ANNO CHRISTI MDCCCC, PRIDIE KALENDAS IANVARIUS . . .

In the year of Christ, 1900,
On the day before January 1,
From Jesus Christ the presages of the Opening Century.

A noble age, fosterer of good arts, is dying.
Whoever cares may commemorate in song
The public conveniences and the forces of nature
That have been brought to light.

More keenly do the errors committed by the declining century
Touch me; for these I grieve and wax wroth.
Oh, shame, how many monuments of disgrace
Do I perceive in looking back.

from a Latin ode by POPE LEO XIII

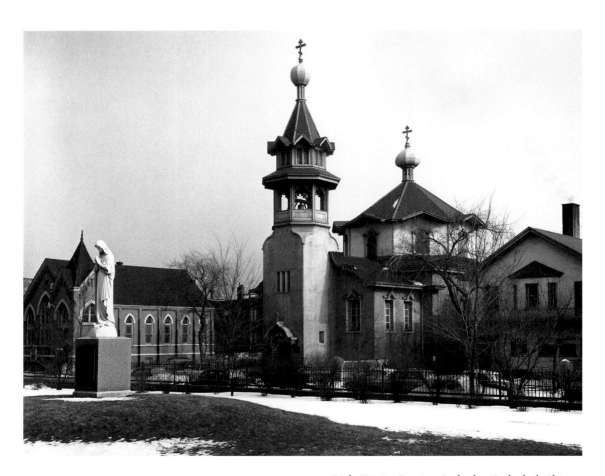

ABOVE AND OPPOSITE: Holy Trinity Russian Orthodox Cathedral, Chicago, 1901–2

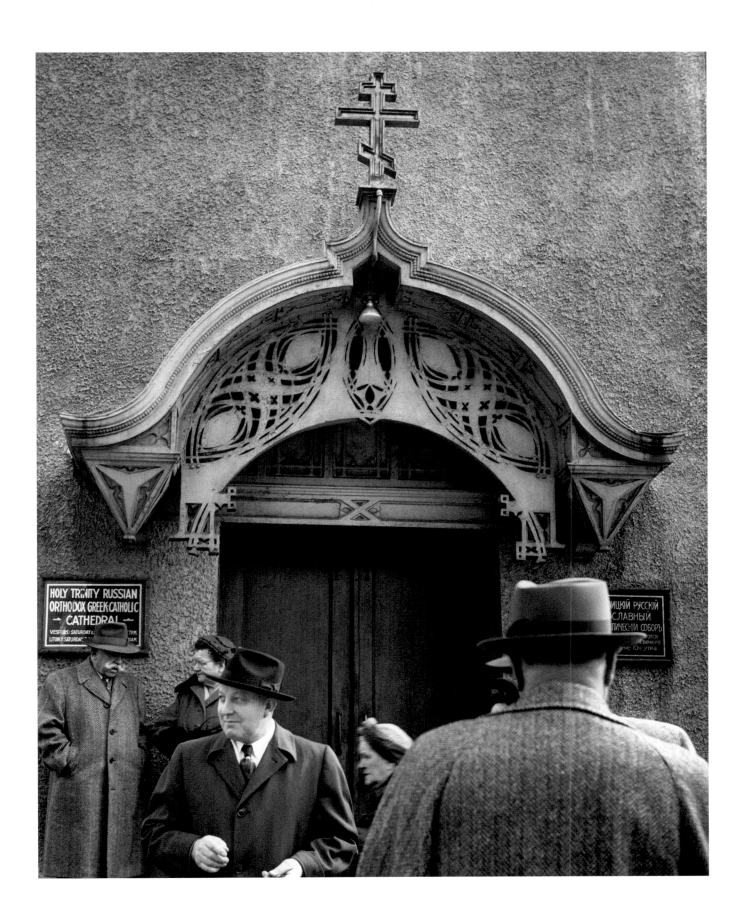

ABOVE AND OPPOSITE: The Bayard (now Condict) Building, New York, 1897–98

VII

DEFEAT: THE CRUCIBLE

Owing to the nature of such creative work as theirs Adler and Sullivan, Architects, had made no money. Their work cost them as much, often more, than they received for it, although they were paid as well as any architects — probably better paid than most. The depression following the Columbian Fair therefore hit Adler and Sullivan hard. At this psychological moment Crane of the Crane Company came along as tempter. He offered Dankmar Adler $25,000 a year to sell Crane Elevators. In a fit of despondency he accepted. Some money had to be earned by someone. Sullivan was left alone, resentful.

The clientele had been mostly Adler's, as Sullivan now found out. And Louis Sullivan soon faced the fact that he was where he must take what was left to him from the Adler connection and start to build up a practice anew. Only one Adler and Sullivan client stayed with the now lonely Sullivan: Meyer, of Schlesinger and Meyer, who employed him to design his new retail store building on State Street.

Some seven years later the Master and I met again. He had gone from bad to worse. The Auditorium management had refused to carry him further in the splendid tower offices, and offered him two rooms below on the Wabash Avenue front.

Later even these were closed to the Master.

His courage was not gone. That would never go. His eyes burned as brightly as ever. The old gleam of humor would come into them and go. But the carriage was not the same. The body was disintegrating.

Now his efficiency was actually impaired by himself. He had increasingly sought refuge from loneliness — frustration — and betrayal where and as so many of his gifted brothers have been driven to do since time was.

Had opportunity opened even this late in his life, he might have been saved for years of remarkable usefulness. But popular timidity and prejudice encouraged by jealousy had built a wall of ignorance around him so high that the wall blinded his countrymen and wasted him. At times his despondency would overcome his native pride and natural buoyancy. Even his high courage would give way to fear for his livelihood. Then all would come clear again. For a while.

FRANK LLOYD WRIGHT, *An Autobiography*

I say present theories of art are vanity. I say all past and future theories of art were and will be vanity. That the only substantial facts which remain after all the rubbish, dust and scientific-analytic-aesthetic cobwebs are brushed away are these facts, which each man may take to himself, namely: That I am, that I am immersed in nature here with my fellow men; that we are all striving after something that we do not now possess; that there is an inscrutable power permeating all, and the cause of all.

And I say that all we see and feel and know, without and within us, is one mighty poem of striving, one vast and subtle tragedy.

On this rock I would stand. And it is because I would stand here, that I say I value spiritual results only and that the best of rules are but as flowers planted over the graves of prodigious impulses which splendidly lived their lives, and passed away with the individual men who possessed these impulses. That is why I say that it is within the souls of individual men that art reaches culminations. That is why I say that each man is a law unto himself; and that he is a great or a little law in so far as he is a great or a little soul.

This is why I say that desire is the deepest of human emotions, and that prudence is its correlative; that it is the precursor, the creator, the arbiter of all the others. That great desire and great prudence must precede great results.

LOUIS SULLIVAN, "What Is the Just Subordination, in Architectural Design, of Details to Mass?"

OPPOSITE AND PAGES 143–51: The Schlesinger-Meyer (now Carson Pirie Scott) Department Store, Chicago, 1899–1904

140

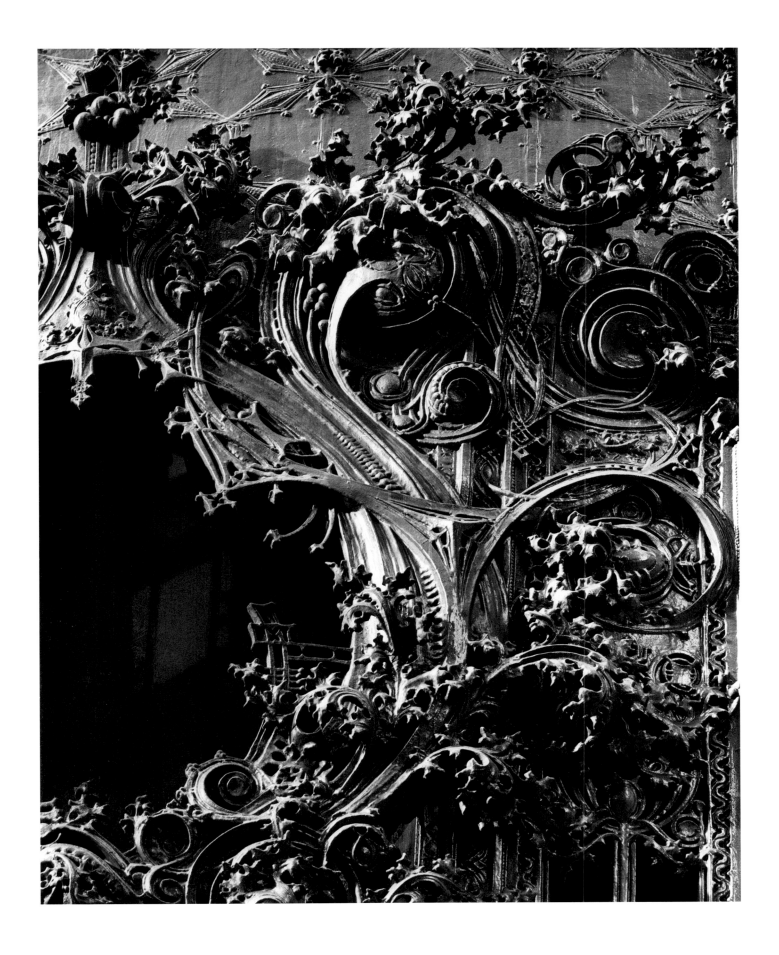

THE ISOLATION OF MEN

THE STUDENT: If it be true, as I have declared, that the true function of the architect is to *initiate* such buildings as shall *correspond* to the *real needs of the people*, how shall I infuse such unmistakable integrity into the word, initiate, the word, correspond, and the phrase, real needs of the people, that mutton-heads and knaves can't use them for their own shameful purposes, by effecting a change of significance in the formula?

THE MASTER: My boy, formulas are dangerous things. They are apt to prove the undoing of a genuine art, however helpful they may be, in the beginning, to the individual. The formula of an art remains and becomes more and more dry, while the spirit of the art escapes, and vanishes forever. The bright spirit of art must be free. It will not live in a cage of words. Its willing home is in boundless nature, in the heart of the people, and in the work of the poet. It cannot live in text-books, in formulas, or in definitions.

THE STUDENT: Yet what am I to do — I must make others understand what I mean.

THE MASTER: You can never make others understand what you mean. It's sheer folly to think of it. That, my boy, is an illusion — a fetish of the learned.

You understand what you understand, and another understands what he understands — and that's a beginning and an end of it. There exists between you and every one of your fellow beings a chasm infinitesimally narrow, yet absolutely uncrossable. The heart cannot cross it, the soul cannot cross it: much less can words cross it. Thus do you, thus does every human being live in the solitude of isolation — whence comes the word *identity*. This isolation is unreachable and unescapable. It is for each one of us a dungeon, or a boundless universe according to the largeness or the littleness of his soul.

So, my boy, do not trouble yourself as to whether or not others understand your words as you do. Seek rather to understand yourself — regardless of words; and in due time, if so it be written in the great book of destiny, others will perceive in your works more or less of what you, more or less adequately, have thought, felt, lived, loved and understood.

LOUIS SULLIVAN, *Kindergarten Chats*

142

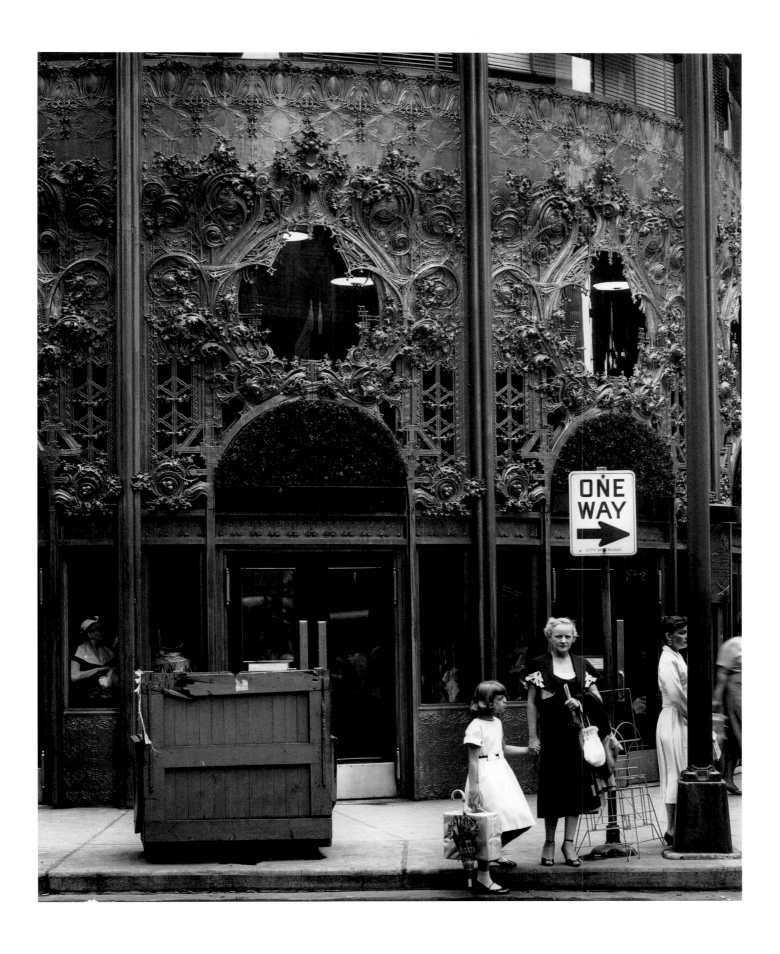

THE TYRANNY OF BUSINESS PRINCIPLES

Something must be done, it is conceived, and this something takes the shape of charity organizations, clubs and societies for social "purity," for amusement, education, and manual training of the indigent classes, for colonization of the poor, for popularization of the churches, for clean politics, for cultural missionary work by social settlements, and the like. These remedial measures whereby it is proposed to save or to rehabilitate certain praiseworthy but obsolescent habits of life and of thought are, all and several, beside the point so far as touches the question at hand.

Nothing can serve as a corrective of the cultural trend given by the machine discipline except what can be put in the form of a business proposition. It is not a question of what ought to be done, but of what is the course laid out by business principles; the discretion rests with the business men, not with the moralists, and the business men's discretion is bounded by the exigencies of business enterprise. Even the business men cannot allow themselves to play fast and loose with business principles in response to a call from humanitarian motives. The question, therefore, remains, on the whole, a question of what the business man may be expected to do for cultural growth on the motive of profits.

THORSTEIN VEBLEN, *The Theory of Business Enterprise*

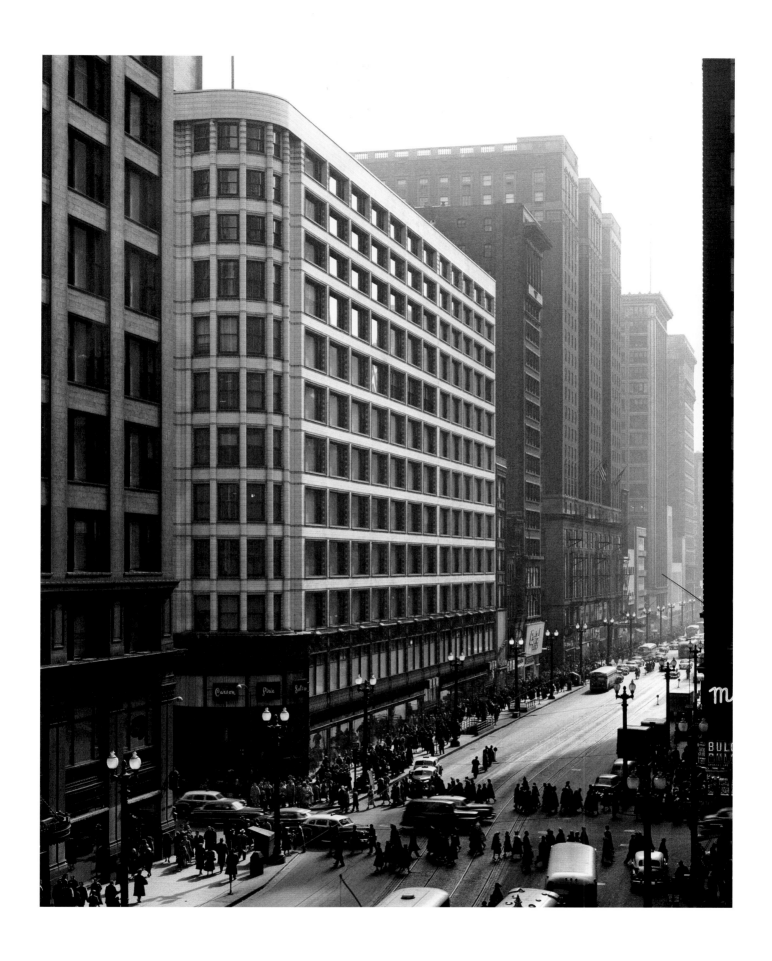

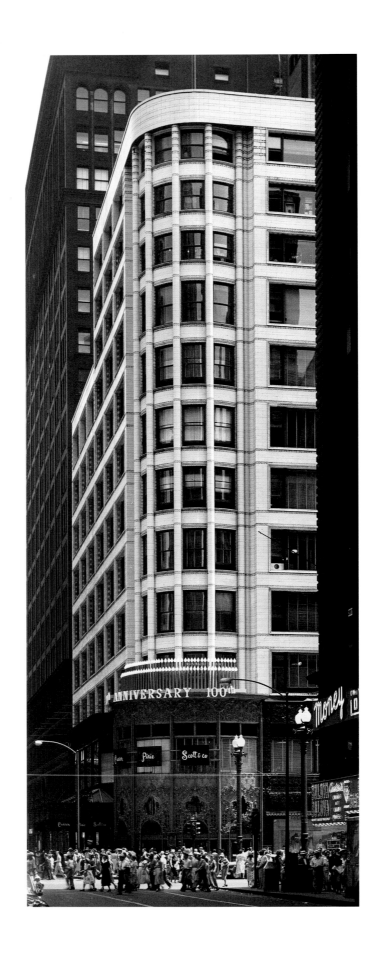

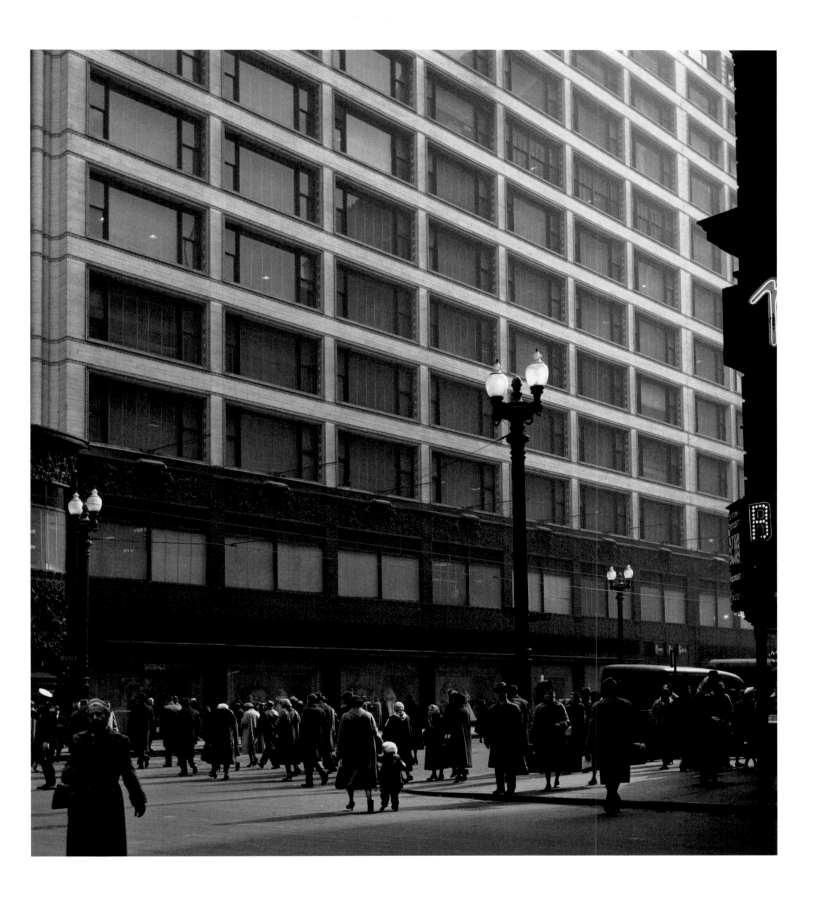

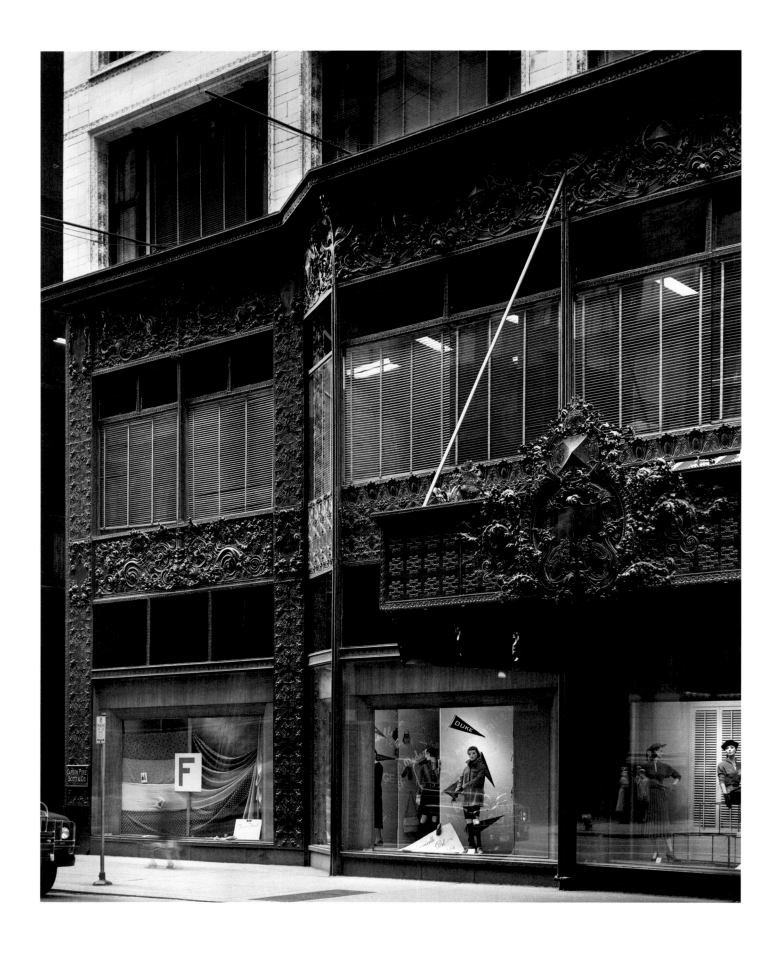

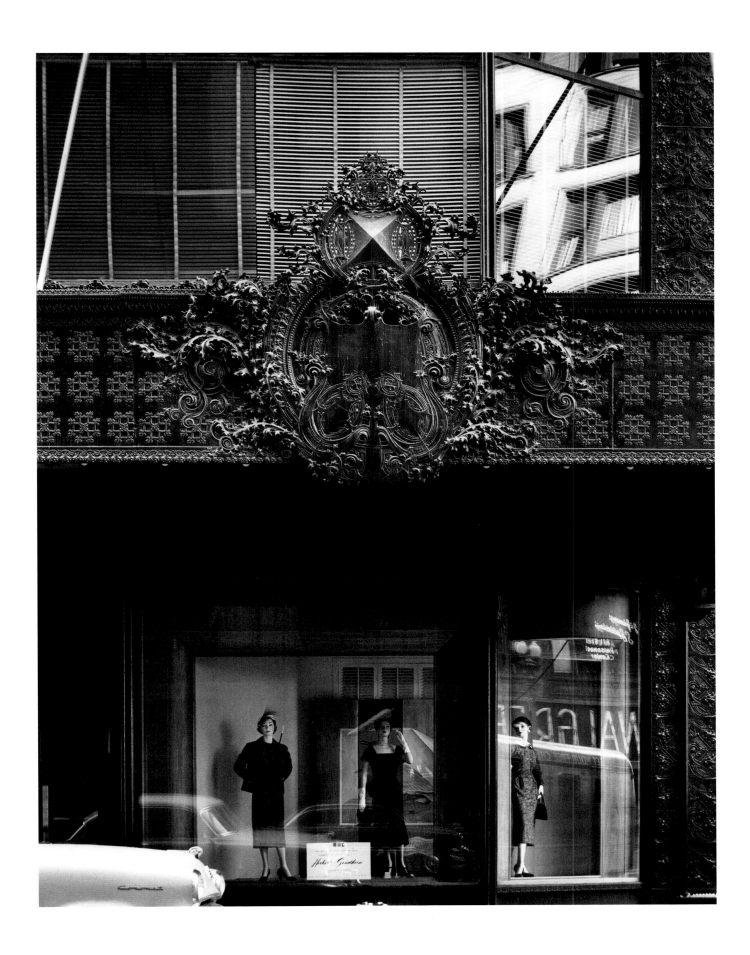

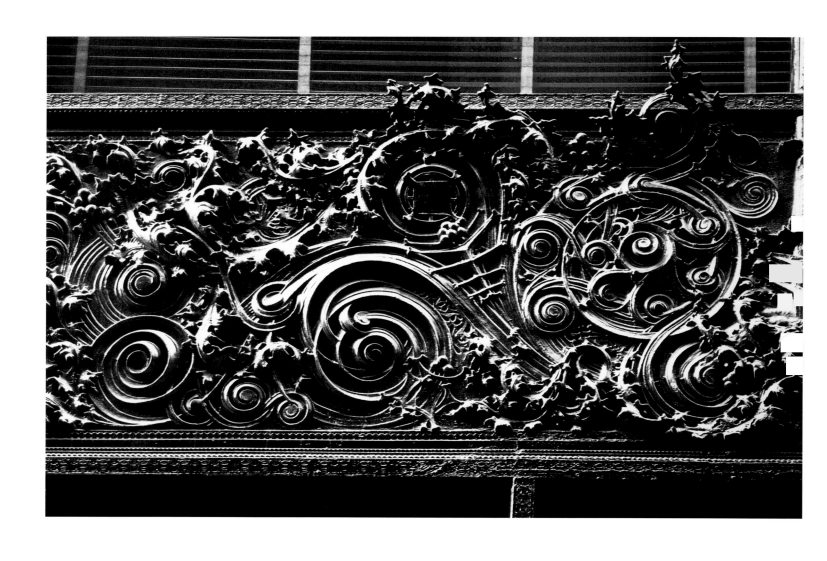

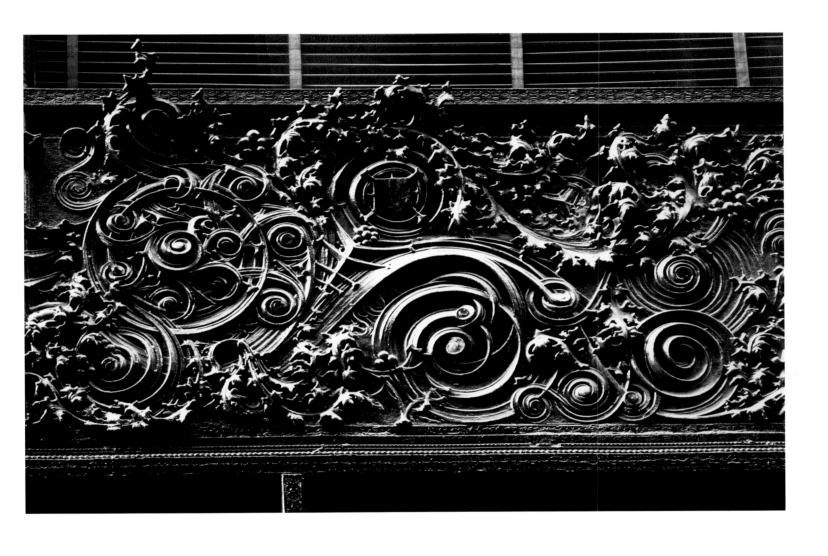

EMINENCE

What can eminence signify without vision, without prophecy, without manifest fulfill-ment — without convincing works?

Is eminence, as we daily view it, more than a counterfeit? Is it above subterfuge, above intrigue, above the low, mean tricks of the high and the clever cogent tricks of the low? Is it far above the cynicisms, pleasant generalizations and practical satisfactions of those who look on their art as on baled merchandise? By and large we have seen, and shall see.

Louis Sullivan, *Kindergarten Chats*

opposite: The Chicago Gold Coast, from Clark Street

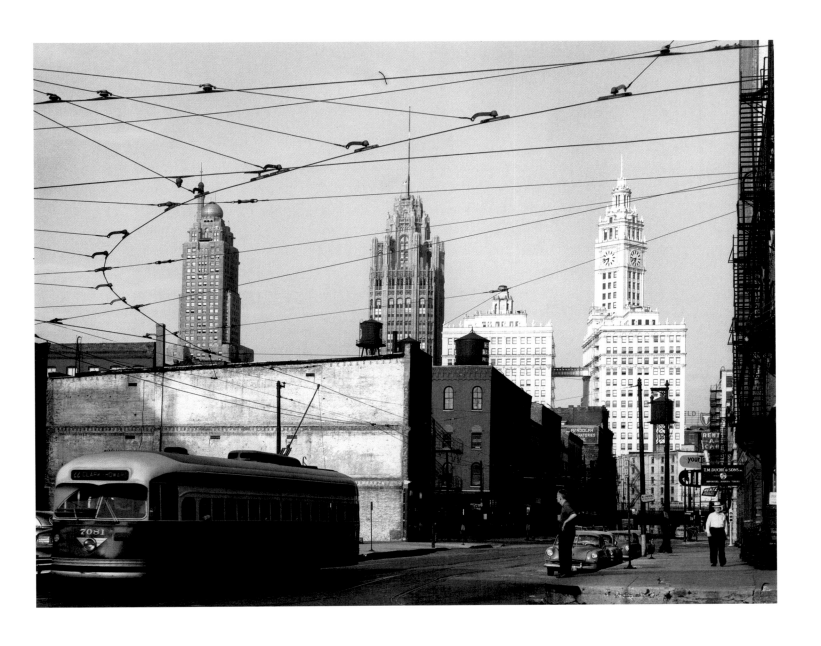

CARL K. BENNETT, vice-president, National Farmers Bank, Owatonna, Minnesota:

The layout of the floor space was in mind for many years, but the architectural expression of the business of banking was probably a thing more felt than understood. Anyhow, the desire for such expression persisted, and a pretty thorough study was made of existing bank buildings. The classic style of architecture so much used for bank buildings was at first considered, but was finally rejected as being not necessarily expressive of a bank, and also because it is defective when it comes to any practical use. Because architects who were consulted preferred to follow precedent or to take their inspiration from the books, it was determined to make a search for an architect whose aim it was to express the thought or use underlying a building, adequately, without fear of precedent — like a virtuoso shaping his material into new forms of use and beauty. From this search finally emerged the name of one who, though possibly not fully understood or appreciated at first, seemed to handle the earth-old materials in virile and astonishingly beautiful forms of expression.

The owners of this building feel that the have a true and lasting work of art — a structure which, though built for business, will be as fresh and inspiring in its beauty one hundred years from now as it is today.

OPPOSITE AND PAGES 156–59: The National Farmers (now Norwest) Bank, Owatonna, Minnesota, 1907–8

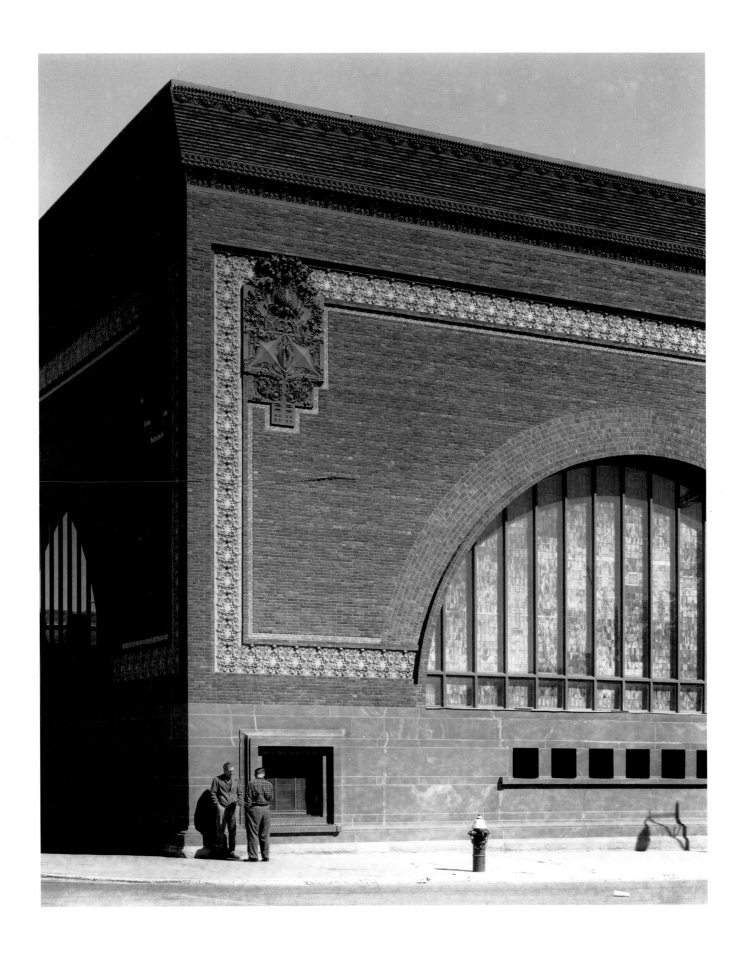

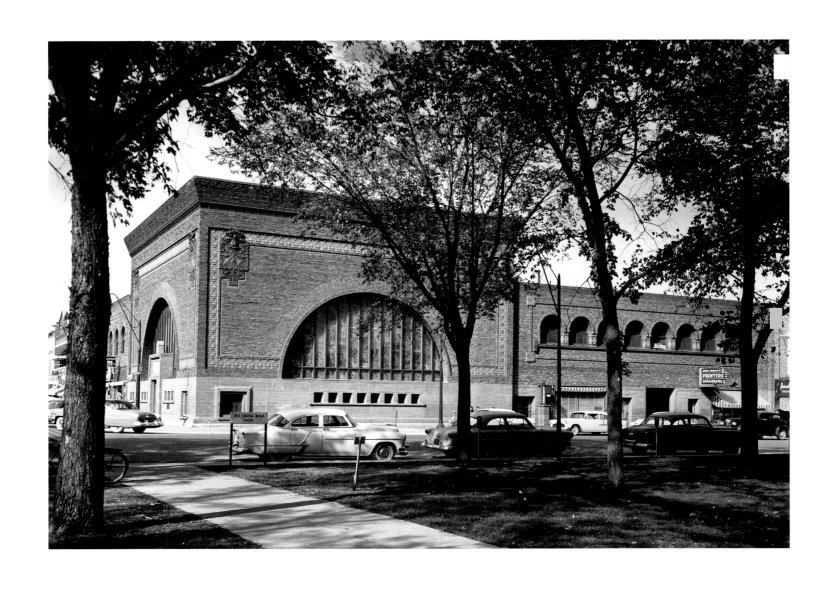

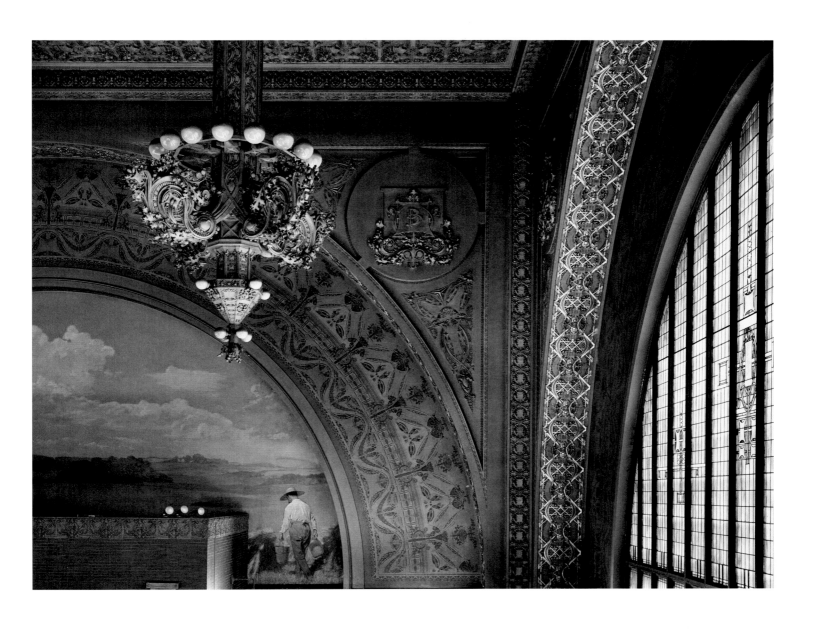

AS YOUR BASIC THOUGHT CHANGES WILL EMERGE A PHILOSOPHY, A POETRY, AND AN ART OF EXPRESSION IN ALL THINGS: FOR YOU WILL HAVE LEARNED THAT A CHARACTERISTIC PHILOSOPHY, POETRY AND ART OF EXPRESSION ARE VITAL TO THE HEALTHFUL GROWTH AND DEVELOPMENT OF A DEMOCRATIC PEOPLE.

As a People you have enormous latent, unused power.

Awaken it.

Use it.

Use it for the common good.

Begin now!

For it is as true today as when one of your wise men said it: — "THE WAY TO RESUME IS TO RESUME!"

LOUIS SULLIVAN, "What Is Architecture: A Study in the American People Today"

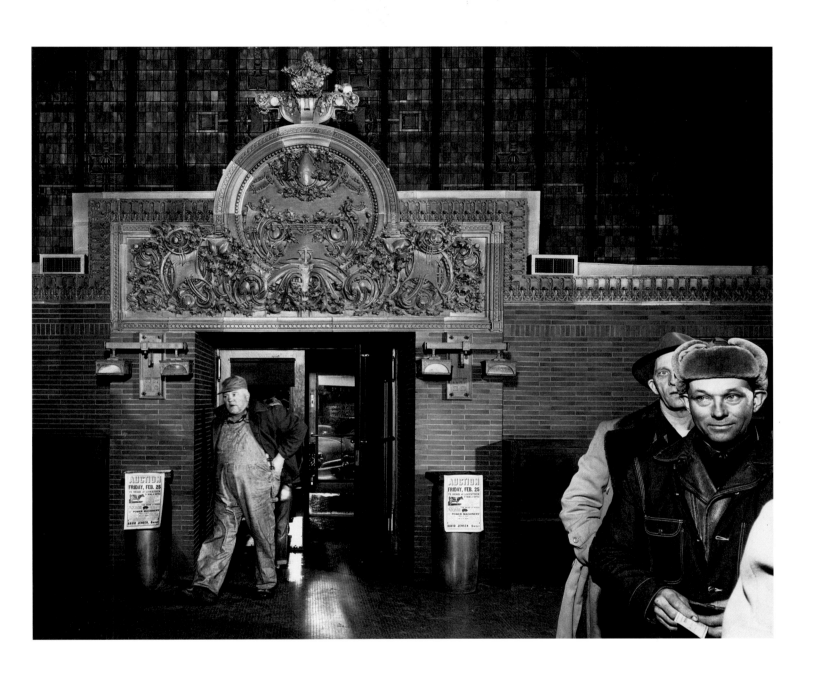

Before my vision as I go,
opens a bewitching landscape —
wherein abides an architecture of peace, of wit and of sanity —
an architecture that shall take on such natural and shapely shapes
that it would seem as though Nature made it; for it will arise
graciously from the mind, the heart, the soul of man;
an architecture which shall seem as though the Lord God made it,
for into it will have been breathed the breath of life —
yet it will be an architecture made by Men —
for men will then have become Men.

LOUIS H. SULLIVAN, from an essay quoted by Elmslie

OPPOSITE: The Guaranty (now Prudential) Building, Buffalo, New York, 1894–95

A TECHNICAL NOTE ON THE PHOTOGRAPHS

THESE PHOTOGRAPHS were made with a 4 x 5 Graphic View camera, or, in perhaps a dozen instances, with an automatic Rolleiflex. The Graphic View was used with three lenses, of 3½", 5½", and 8¼" focal lengths. The Super XX film was developed in D-23 or Microdol. The original prints were made by an Omega D condenser enlarger on Varigam paper, developed in Amidol, Dektol, or Ardol, and toned to a slight cool brown in selenium.

The extreme darkness of many of the buildings, now covered with the dirt of sixty years, frequently required very heavy exposure, and correspondingly gentle development. The resulting negatives — of full opacity but low contrast — often required full exploitation of the variable contrast potential of Varigam paper, the dark shadowed areas being printed to a high contrast, the bright sunlit areas, softer.

In photography, as elsewhere, there are no technical problems — only technical solutions. The problem itself always is the nontechnical one of discovery and understanding. Throughout this work the attempt has been to allow the discovery of the subject to dictate photographic technique. Neither architectural nor photographic preconceptions — "ideas" — have been allowed precedence over perception: the experience of the eye and mind when faced by the subject fact.